THE BLACK & WHITE BOOK

COLORWORKS 5

THE
BLACK
&
WHITE
BOOK

DALE RUSSELL

NORTH
LIGHT
BOOKS

Cincinnati, Ohio

A QUARTO BOOK

Copyright © 1990 Quarto Publishing plc
First published in the U.S.A. by North Light Books, an imprint
of F & W Publications, Inc.
1507 Dana Avenue
Cincinnati, Ohio 45207

ISBN 0-89134-341-5

This book was designed and produced by
Quarto Publishing plc
The Old Brewery
6 Blundell Street
London N7 9BH

SENIOR EDITOR Sally MacEachern
EDITORS Paula Borthwick, Eleanor van Zandt
DESIGNERS Penny Dawes, David Kemp, Julia King, Karin Skånberg
PICTURE MANAGER Joanna Wiese
PICTURE RESEARCH ADMINISTRATION Prue Reilly, Elizabeth Roberts
PHOTOGRAPHERS Martin Norris, Phil Starling
With many thanks to Edward Chan and Francis Ho
for all their hard work on the *Colorworks* series.

ART DIRECTOR Moira Clinch
EDITORIAL DIRECTOR Carolyn King

Manufactured in Hong Kong by Regent Publishing Services Ltd
Typeset by Ampersand Typesetting Ltd, Bournemouth
Printed in Hong Kong by C & C Joint Printing Co. (H.K.) Ltd

DEDICATION
With great love, I would like to thank my husband Steve for
patiently guiding me through the days and nights overtaken by
color and my daughter Lucy Scarlett for remaining happy
while color came first.

The color tints printed in this book have been checked and
are, to the publisher's knowledge, correct. The publisher can
take no responsibility for errors that might have occurred.

CONTENTS

THE COLORS

22

Using Colorworks

To make the most of the *Colorworks* series it is worthwhile spending some time reading this and the next few pages. *Colorworks* is designed to stimulate a creative use of color. The books do not dictate how color should be applied, but offer advice on how it may be used effectively, giving examples to help generate new ideas. It is essential to remember that *Colorworks* uses the four-color process and that none of the colors or effects use the special brand name ink systems.

The reference system consists of five books that show 125 colors, with 400 type possibilities, 1,000 half-tone options, and 1,500 combinations of color. But even this vast selection should act only as a springboard; the permutations within the books are endless. Use the books as a starting point and experiment!

When choosing colors for graphic design it is almost impossible to predict the finished printed effect. In order to save valuable time spent researching, you can use the series' extensive range of colors to provide references for the shade with which you are working.

The four process colors

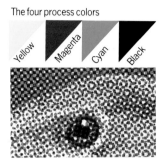

▲ Enlarged detail showing how four process colors overlap to produce "realistic" color.

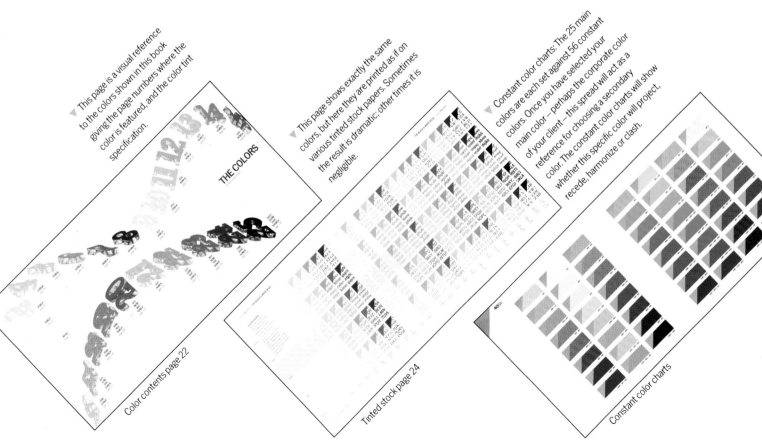

▼ This page is a visual reference to the colors shown in this book giving the page numbers where the color is featured, and the color tint specification.

Color contents page 22

▼ This page shows exactly the same colors, but here they are printed as if on various tinted stock papers. Sometimes the result is dramatic, other times it is negligible.

Tinted stock page 24

▼ Constant color charts: The 25 main colors are each set against 56 constant colors. Once you have selected your main color – perhaps the corporate color of your client – this spread will act as a reference for choosing a secondary color. The constant color charts will show whether this specific color will project, recede, harmonize or clash.

Constant color charts

The books are ideal for showing to clients who are not used to working with color, so that they may see possible results. They will also be particularly useful when working with a specific color, perhaps dictated by a client's company logo, to see how this will combine with other colors. Equally, when working with several colors dictated by circumstances – and perhaps with combinations one is not happy using – you will find that the constant color charts, colorways and applications will show a variety of interesting solutions. The numerous examples in *Colorworks* can act as a catalyst, enabling you to break out of a mental block – a common problem for designers who may feel that they are using a wide variety of colors but actually be working with a small, tight palette.

Finally, when faced with a direct color choice, you should use *Colorworks* in the same way you would use any other art aid – to help create the final image. The books are designed to administer a shot of adrenaline to the design process. They should be treated as a tool and used as a source of both information and inspiration.

TERMINOLOGY USED IN COLORWORKS

Main color: one of the 25 colors featured in each book.

Colorway: The main color plus two other color combinations.

Constant color: The main color with 56 constant colors.

Y: yellow
M: magenta
C: cyan
Blk: black
H/T: half-tone
F/T: flat-tone

TECHNICAL INFORMATION

When using *Colorworks*, or any color specification book, remember that paper stock, lamination and type of ink can change the effect of chosen colors. Coated papers, especially high quality, tend to brighten colors as the ink rests on the surface and the chalk adds extra luminosity, while colors on uncoated paper are absorbed and made duller. Lamination has the effect of making the color darker and richer.

Colorworks specification

Color bar: GRETAG
Screen: 150 L/IN.
Film spec.: AGFA 511P
Tolerance level: + 2% − 2%
Col. density: C = 1.6 – 1.7
　　　　　　 M = 1.4 – 1.5
　　　　　　 Y = 1.3 – 1.4
　　　　　　 Blk = 1.7 – 1.8
Ink: Proas
Paper: 135gsm matt coated art
Plate spec.: Polychrome
Dot gain: 10%
Printed on: Heidelberg Speedmaster 102v
Printing sequence: Black/Cyan/Magenta/Yellow

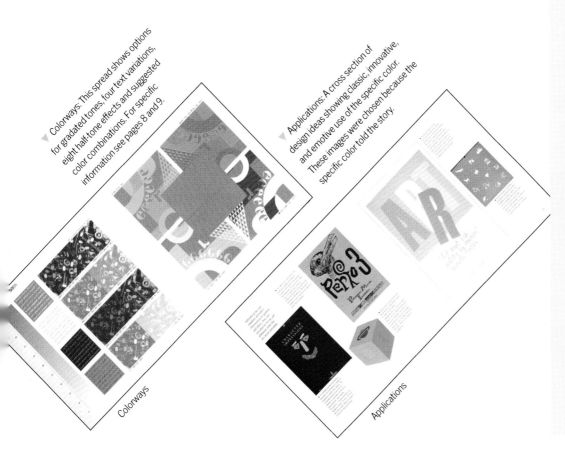

Colorways: This spread shows options for gradated tones, four text variations, eight half-tone effects and suggested color combinations. For specific information see pages 8 and 9.

Applications: A cross section of design ideas showing classic, innovative, and emotive use of the specific color. These images were chosen because the specific color told the story.

Colorways

Applications

On the next four pages you can see, in step-by-step form, exactly how to understand and use the color reference system shown in *Colorworks* and how you can incorporate the ideas into your designs.

It is essential to remember that *Colorworks* uses the four-color process – none of the effects uses the special brand-name ink systems – usually described as "second colors."

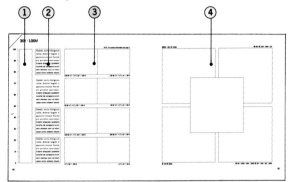

1. GRADATED COLOR

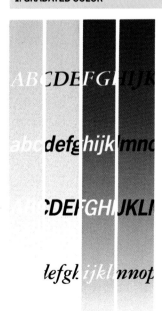

The color scale shows the main color fading from full strength to white. If you are using a gradated background, the scale clearly demonstrates at what point reversed-out type would become illegible – with a dark color you may be able to reverse out down to 20% strength, with a pastel only down to 80%, or perhaps not at all, in which case the type should be produced in a dark color.

The opposite would be true if the design incorporated dark type on a fading dark color. Again, unless a very subtle result is required, the scale indicates at what point type would become illegible.

The other use of the fade gives the designer more color options – perhaps you like the color on page 102, but wish it was slightly paler. With the gradated shading you can visualize just how much paler it could be.

2. TYPE OPTIONS

The main color with different type options; solid with white reversed out; type printing in the color; black and the type reversed out as color; solid with black type. These examples demonstrate the problems of size and tonal values of the type.

The type block is made up of two typefaces, a serif and sans serif, both set in two different sizes.

┌9pt New Baskerville
 ┌7pt New Baskerville
Ossidet sterio binignuis
gignuntisin stinuand. Flourida

┌trutent artsquati, quiateire
semi uitantque tueri; sol etiam

└8½pt Univers 55 └7pt Univers 55

Size
Using the four-color process the designer obviously has no problems choosing any combination of tints when using large type, but how small can a specific color type be before it starts to break up or registration becomes a problem? The type block shows when the chosen tints work successfully and more important *when they do not*.

Ossidet sterio binignuis tultia, dolorat isogult it

9pt New Baskerville: 80% Blk demonstrates no problems.

gignuntisin stinuand. Flourida prat gereafiunt quaecumque

7pt New Baskerville 20%Y 30%M 40%C 20% Blk the serifs start to disappear.

Tonal values
Obviously, when dealing with middle ranges of color, printing the type black or reversed out presents no legibility problems. But the critical decisions are where the chosen colors and shade of type are close. Will black type read on dark green? Will white type reverse out of pale pink? When marking up color, it is always easier to play safe, but using the information in *Colorworks* you will be able to take more risks.

The problem is shown clearly above: using a pastel color (top) it would be inadvisable to reverse type out; with a middle shade (center) the designer can either reverse out or print in a dark color; while using a dark color (bottom), printing type in black would be illegible (or very subtle).

3. HALF-TONE OPTIONS

This section demonstrates some possibilities of adding color to black and white half-tones where the normal, "realistic" four-color reproduction is not desired or when the originals are black and white prints. This section gives the designer 800 options using various percentages and combinations of the process colors.

100% main color	**50% strength of main color**

100% black H/T plus full strength of the main color	100% black H/T plus 50% of the main color

50% black H/T plus full strength of the main color	50% black H/T plus 50% of the main color

100% black H/T plus a *flat* tint of the main color at full strength	100% black H/T plus a *flat* tint of the main color at half strength

H/T using only the main color at full strength	H/T using only the main color at half strength

Moiré pattern

Some of the main colors in this book include percentages of black. If this film is combined with the black film from the half tone a moiré pattern can occur. To overcome this possibility the films for *Colorworks* have been prepared in two ways. When the main color is made up of 3 colors or less, e.g. p110 and 118, the two black films have been specially angled. When the main color is made up of four colors plus the extra black (e.g. p128) it is impossible to create an extra screen angle. In order to give the effect of the extra black, the repro house has strengthened the black H/T dot in the mid tones and highlights by the appropriate percentage. This darkens the highlights, making the halftone flatter and richer. However, slight moiré pattern will occur on the flat tint section.

Discuss this with your repro house if you want to use B/W halftones made up with two blacks.

4. COLORWAYS

This page shows the main color with other colors. It acts as a guide to help the designer choose effective color for typography and imagery. Each color is shown as four colorways; each colorway shows the main color with two others.

The three colors in each colorway (corner) are in almost equal proportions. The effect would change dramatically if one color was only a rule or small area. Use the colorways to find the appropriate range for your design and adapt it accordingly.

For information on using the central square and its use in commissioning photography or illustration see page 10.

The choice of color has not been limited to the safe options. The easy neutrals cream, white, and gray have been used, but so have more unusual combinations.

The colors chosen show various effects; look at each corner, if necessary isolating areas.

▼ Colors are shown projecting forward, sometimes using the laws of optics which say that darker, cooler shades recede.

▲ Sometimes, due to the proportions, defying them.

▲ There are classic color combinations.

▲ Colours that are similar in shade.

abcdefghi

▲ Use these colors for background patterns, illustrations or typographic designs where the color emphasis has to be equal.

▲ These colors are not advisable if your design needs to highlight a message.

Analyze your design to see how dominant the typography, illustrations, and embellishments need to be versus the background, then use the colorways to pick the appropriate colors or shades.

When selecting colors, it is very important to eliminate any other color elements that might affect your choice. As has been demonstrated in the color optics section (p14), the character of a color can be dramatically changed by other, adjacent colors.

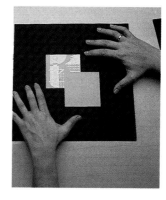

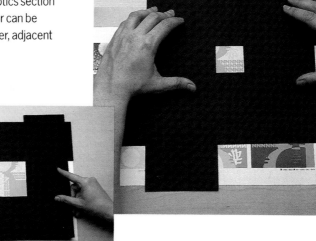

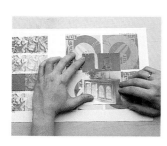

◀▲ The colorways have been designed in such a way that you can mask out the other color options – isolating the area you want to work with or even small sections of each design.

▼▶ The colorways can also be used if you are selecting the color of typography to match/enhance a photograph or illustration; again masking out the other colorways will help. A print of the photograph or illustration can be positioned in the central area, and the mask moved around.

Useful mask shapes

The design shown on this page was created to demonstrate the practical use of *Colorworks*. It combines many half-tone effects and color combinations.

The options illustrated are drawn from *The Black and White Book*. For more suggestions and further inspiration, refer to the other books in the series.

▶ Using elements from *The Black & White Book* pages 86-87, 88-89.

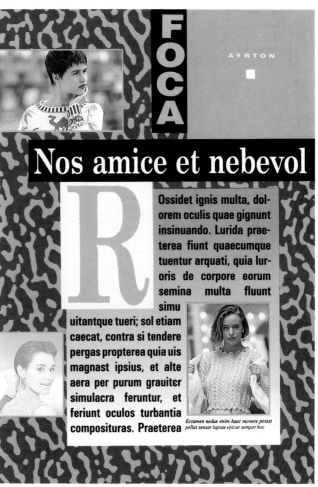

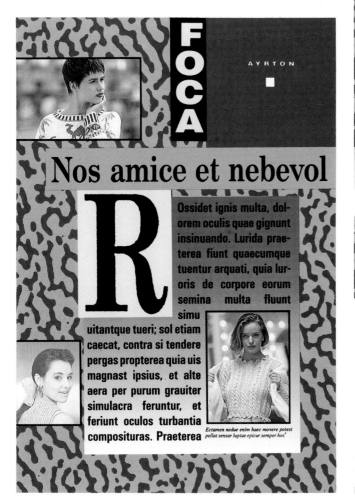

◀ Using elements from *The Black & White Book* pages 44-45, 46-47.

Black & white introduction

*"Of the colour of jet or carbon black, having no hue due to the absorption of all
or nearly all incident light. "*
"Having no hue due to the reflection of all or almost all incident light. "

Collins English Dictionary; Publishers William Collins Sons and Co. Ltd., London and Glasgow; Second Edition 1986

"Of the very darkest color, like coal or soot. "
"Of the very lightest color, like snow or common salt. "

Oxford American Dictionary, Publishers Oxford University Press, New York, U.S.A. 1980

Color is not tangible; it is as fluid as a musical note. Although it may be described, the verbal or written words often bear no relation to its actual form. Color has to be seen in context, for a single shade used in conjunction with another color can take on a whole new character. Searching for a particular shade can be very confusing – somewhat like humming a tune and searching for a forgotten note.

No matter how much theory exists, it is the eye of the designer or artist that is responsible for using color creatively. The fact that color can be rationalized and then break its own rules with complete irrationality is what makes it so fascinating.

This book is about process color. By the very nature of the process system, colors are not blended, as with pigments, but shades are selected visually. Unlike pigment colors, process colors can be mixed without losing any of their chromas. The process primary colors are magenta, yellow, and cyan, with black to create density and contrast, allowing dot saturation to establish values of lightness and darkness. The pigment primaries are red, blue and yellow.

The concept of process color is not really new. The German poet and scientist Goethe (1749-1832) looked at effects of light and darkness on pigment color in a way that strongly relates to modern interpretation of process color. In complete contrast, a practical approach was taken by the 20th-century German painter Hickethiev, who created a precise notation system based on cyan, magenta, and yellow for printing. Between these two extremes lies the concept of the process color system.

The colors used in these books had to be systematically chosen to prevent *Colorworks* from dating or the colors from being a purely personal choice. It was important to rely on theory and I finally selected over a thousand colors for the five books that make up this series. This meant working with literally thousands of colors, and yet in spite of this comprehensive palette, there would still be a precise shade that would remain elusive.

My next major task was to select each image from advertising agencies, design consultancies, illustrators, and actually "off the walls." Every piece of printed matter, label, shopping bag or magazine was a potential gold mine of material for the books. Many images had to be excluded,

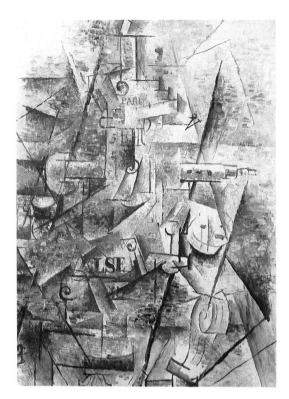

*Clarinet and bottle of rum on a mantlepiece by Georges Braque
(1882-1963) A sensitive palette of tinted grays creates an apparently
monochrome image. The subtle use of ochered gray brings warmth
to this cubist composition.*

even though they had superb coloration, because they did not tell a story with one predominant color.

Colorworks examples had to have immediate impact, with one color telling the story – whether in harmony with others, through shock tactics, providing a backdrop, creating a period setting, making instant impact for the recognition of the image content, or simply combining superb color use with design.

Color combinations are infinite, and every day wonderful examples of color and design are being created. Having drawn from just some of these, I hope the *Colorworks* series will be a reference to inspire, confirm, and enjoy.

Dale Russell

Optical illusion, proportion, and texture

Black and white are the basic colors of printing. Black is a process color, whereas white is the color of the paper on which the process system is normally printed. Black absorbs nearly all reflected wavelengths; white absorbs almost none. They are the two extremes; between them lies the whole continuum of shades of gray, using percentages of black. Gray is achromatic, a chameleon that is capable of being influenced by more dominant colors.

The optical effect of black on white offers infinite possibilities, for it is dependent only on line or pattern, and its extreme contrast will always provide clarity and high visibility. The same can be said of these colors when reversed.

It was in the 18th century that the importance of using varying shades of black in conjunction with the primary colors was first recognized. Moses Harris, a British engraver of this period, created a color circle using the three primary colors, shading them with black to produce 18 distinct hues. Using intensities of black tint and a series of black lines drawn increasingly close together, Harris produced an effect of growing intensity and color change. The mixing of primary colors can create a varied palette, but with the addition of black this palette becomes infinite.

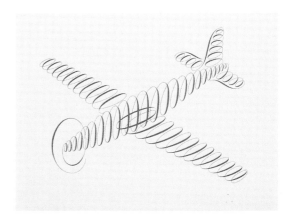

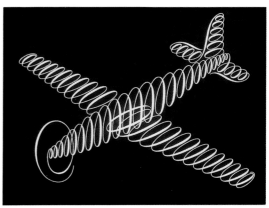

▲ Black spiralled graphics give the illusion of a light airplane flying with ease through a pure white sky. A white image of an identical airplane is given weight and body by the dense black sky.

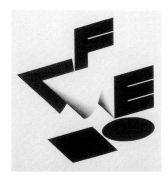

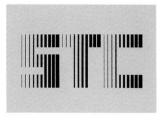

▲ A sense of action and movement is recreated by the progressing intensity of black. As the percentages of black increase, the strength of the line becomes more dominant. The black line at the end of each letter has the effect of punctuation, separating the action within each letter of the company logo.

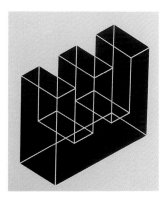

▲ This optical illusion follows the classic lines of master illusionists such as Escher. The illusion within this geometric design is formed by the clarity and precision of the white linear graphics against the density of the solid, black form.

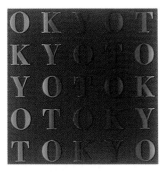

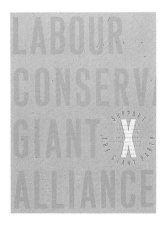

▲ ▲ Black against white, white against black – the juxtaposition of these contrasting hues creates the illusion of solid forms. These are not just geometric shapes applied to a white background; with the addition of low percentage shading, they become three-dimensional objects with exaggerated shadows.

▲ The colors of the spectrum have been applied to the typography, creating the illusion of movement through the changing dark and light intensities of the colors. The black projects the hues in varying degrees, increasing the sense of movement.

▲ Soft mole gray, with a percentage of magenta, provides a warm background which projects the sulphur lettering; yet it is the single white graphic that commands attention. Proportion and a range of tone within the hues are used to display a message with minimal application and maximum effect.

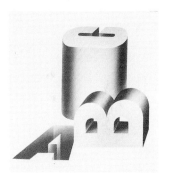

▲ An impression of solid, three dimensional forms is created by employing optical illusion to provide depth and form. The effect is achieved by using fading percentages of black against a solid white background.

Psychology

Black and white are direct opposites. Black represents night and is the color of mourning. It is evocative of witches, covens, and magic. Black magic and supernatural forces have given black a sense of mystery. Fear of the night and claustrophobia in darkness can be associated with black. On the other hand, black also epitomizes sophistication and has overtones of sexuality.

White represents purity, and is the color traditionally associated with virgins – hence the white wedding dress. White signifies truth and innocence. It is commonly regarded as the color of good, as opposed to the association of black with evil. Yet in war, white is the color of surrender – the white flag – and of cowardice: in the past, cowards were presented with a white feather. White also has connotations of sterility, of clinical cleanliness, and of cold. Here again, however, there are two different associations: the bleakness of a snowdrift and the soft gentleness of a feathery snowflake. White can also convey simplicity and uncluttered sophistication.

Between black and white lies the "gray area". The very word "gray" has connotations of common sense, calmness, and sobriety: the cloudy gray sky, the sad grayness of depression, the conformity of the gray-suited businessman. However, in the West in the 1980s, gray is associated with contemporary fashion, chic packaging and avant-garde design.

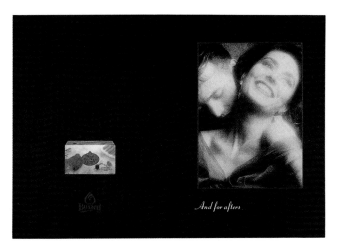

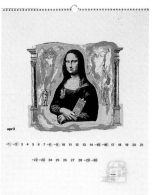

▲ The use of unconventional hues – mauve, primrose and olive drab – gives the familiar image of the Mona Lisa a haunting quality that is quite bizarre. The unexpected combination of historical imagery and a contemporary palette creates a memorable image.

▲ Black tells us that it is evening and conveys an undercurrent of sexuality. The minimal addition of scarlet confirms this second association and brings the eroticism to the foreground. The gentle tint on the photograph, suggesting candlelight, introduces a softening element of romance. The red brings us to the logo and highlights the product – a cordon bleu chicken dinner.

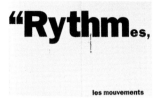

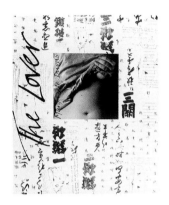

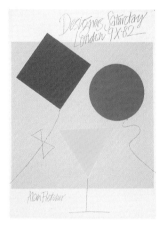

▲ The three elements of this design each form part of a story. The psychological impact made by the sensual tinted photograph is heightened by the minimalist black calligraphy layered on contrasting white. The intimate, handwritten title reveals the plot.

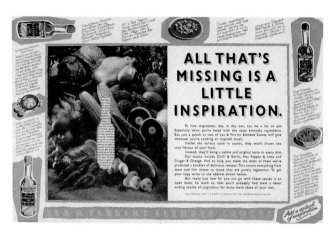

▲▲ The psychological reaction to the change in size of the typeface is to feel a sense of motion, or rhythm.

▲ Anonymous pale gray forms a welcoming backdrop in contrast to the crisp white border. The psychological association of fun and activity with bright and cheerful primary shades is confirmed by fine graphite lines that reveal balloon strings and the stem of a wine glass.

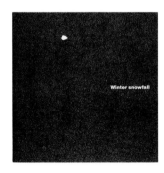

▲ The association of gray with anonymity, dullness, and boredom is used by the art director to underline the copy headline, "All that's missing is a little inspiration." The addition of a gray background to the artwork emphasizes the anonymous bottle which appears to have been cut out of the color photograph, thus becoming the vital missing ingredient.

▲ The manipulation of identity and atmosphere is achieved by creative application of individualistic black-on-white lettering. The free form movement, achieved through semi-abstract graphics combined with a controlled typeface, allows an intellectual story to be told by the type alone.

▲ Black is used to create the atmosphere of deepest, darkest winter. A small white fleck is transformed into a falling snowflake. The pure white typographic statement confirms the imagery and enhances the impact of the snowflake.

Marketing

Black packaging has a sophisticated appeal which makes it appropriate for select-quality merchandise appealing to customers who respond to an elegant, understated image. Black has overtones of sexuality, whether alone, or combined with sultry shades such as purple. Gray implies a durable and dependable product offering utilitarian good value and discreet sophistication. Gray plays a strong role in "street" design and fashion; its intrinsic neutrality offers design application using minimalist color.

White can imply cleanliness and purity, or sophistication and style, or functional efficiency, depending on the presentation. By using white, the designer can imply truth and innocence, through color association within a design. The most effective use of white is as the secondary color, either providing visibility and impact or creating a backdrop. In either role it is found on all forms of packaging and design.

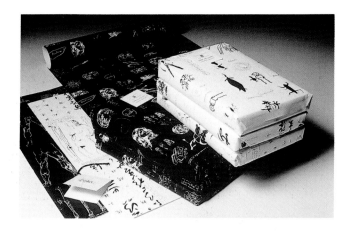

▲ Here the palette is restricted to black and white, employed in numerous permutations. Through the use of reversal and overlay, combined with experimental application, a variety of textures and images appear within a single coordinating range. The combination of the sophisticated negative/positive colorway, and the simple modernist graphics is aimed at the discriminating purchaser.

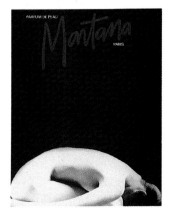

▲ The sensual imagery of this erotic advertisement is complemented by the sultry electric blue of the calligraphy which smoulders above the model. The black background intensifies the sexual atmosphere. This advertisement is aimed at the specific market of those who prefer an overtly sensual scent; every detail reinforces this image, including the tattoo of the logo on the model's shoulder.

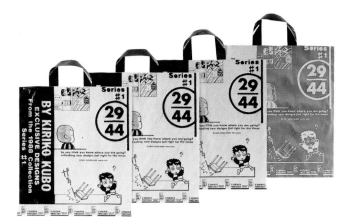

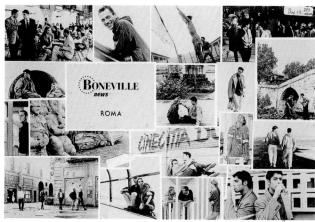

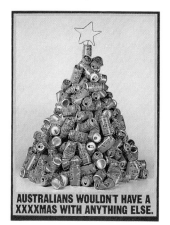

▲ A series of subtle tints have been applied to black-on-white graphics, and the range is made even more interesting by the reversal of graphics and type on the darkest of the tints. This use of color has given the range continuity without losing the contemporary look, which is aimed at a young design-conscious market.

▲ A collage of photographic images, together with the title "News" implies that this is more than just a fashion advertisement. It appeals to the discerning young person who is interested in fashion but insists that it reflect his or her lifestyle. The taupe tint underlines this feeling while giving the photographs an air of elegance.

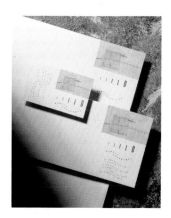

▲ The marketing people are aware that most consumers already know what XXXX is, so they are able to assume that the viewer will decipher the advertisement. The use of an oyster gray background for a Christmas theme continues this reversal of the norm. The sunny glow of chrome and scarlet reminds us that when it is cold and snowing at Christmas in the northern hemisphere, it is hot and sunny in Australia.

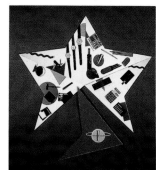

▲ This combination of bright color with black and white retains the sophistication of the products, while the advertisement appeals to a broad range of consumers.

▲ The continuity of logo and style shows an approach to marketing that is subtle and distinctive. This is a public relations company, and therefore its logo needs to have immediate impact. The discreet palette of muted pastel shades complements the black typography overlaid on the contrasting white background. This is a contemporary image with strong clarity.

Culture and period

Over the years black has had numerous resurgences of popularity – notably in the Art Deco design of the 1920s and more recently, almost to the exclusion of any other color, during the mid-1980s.

White shared the popularity of black during these periods; together with gray, these colors embodied a sophisticated approach to coloration and style. Earlier gray had been an important part of the Victorian palette, standing for a sober, puritanical attitude to life. It then found a new role in the postwar years of the 1940s and the early Fifties, when shades of gray dominated "utility" fashion and design in Britain.

In most countries black represents death and is worn for mourning. In Egypt, however, black represents rebirth. Besides being worn by brides in Western countries, white is also the color of christening gowns. It is however, the traditional mourning color in China.

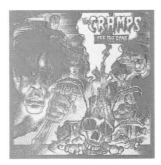

▲ This album cover could illustrate any section of this introduction. The 1980s pastiche of a 1950s experiment with three-dimensional color epitomizes youth culture through its creative use of color and design. Experimenting with complementary colors and registration is typical of the open-minded design of the early 1980s.

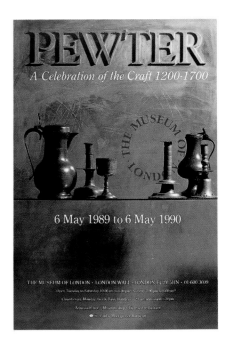

▲ Although this poster is for an exhibition in 1990, its use of color spans centuries. The textural application of pewter gray is totally appropriate to the subject of the exhibition. The addition of the red logo introduces a contemporary note, as does the white type. The dominance of the pewter gray, however, ensures that the paramount idea is that of traditional craftsmanship.

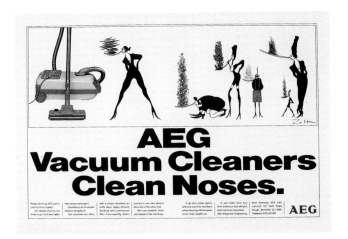

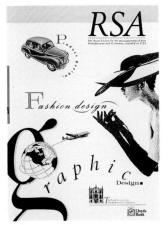

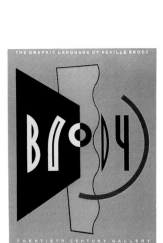

▲ This is a modernist approach to color and to a sales campaign. By making the product merely a character within the plot of the advertisement, the company demonstrates its complete confidence in the product.

▲ This 1950s celebration of color and design is, in fact, subdued if you analyze the colors chosen. The predominant color is black, with turquoise, chrome, and grenadine red creating Cubist intensities and tones. The poster is encouraging the use of color, and gives the impression of simplicity, but the color and design are in fact complex and original.

▲ This poster for the Royal Society of Arts captures a 1950s period atmosphere to perfection. The application of discreet toning color to the black and white graphics and background has achieved a design that combines authenticity with originality.

▲ The Twentieth Century Gallery, in London, celebrates contemporary graphics and color with an exhibition by Neville Brody. This poster – in its complex interplay between color and design – epitomizes the controlled and yet anarchistic approach to design taking place during the late 1980s.

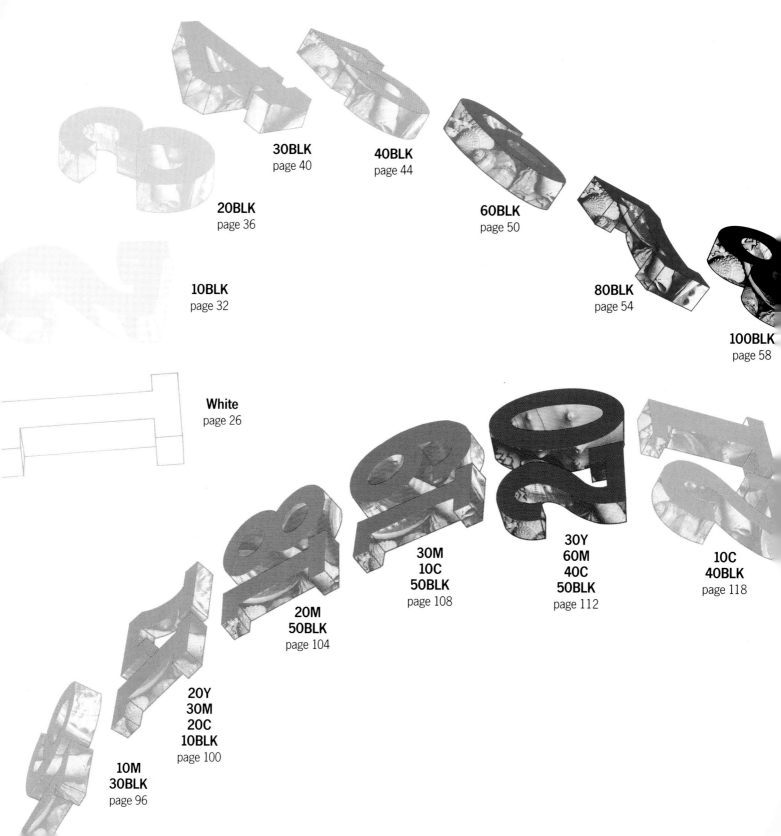

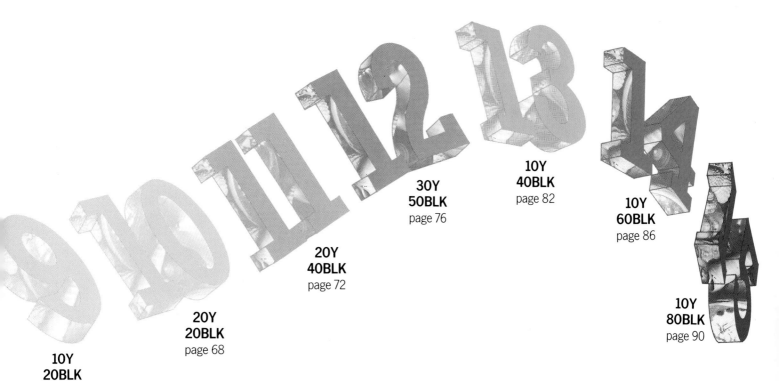

10Y
20BLK
page 64

20Y
20BLK
page 68

20Y
40BLK
page 72

30Y
50BLK
page 76

10Y
40BLK
page 82

10Y
60BLK
page 86

10Y
80BLK
page 90

THE COLORS

Numbers are percentages

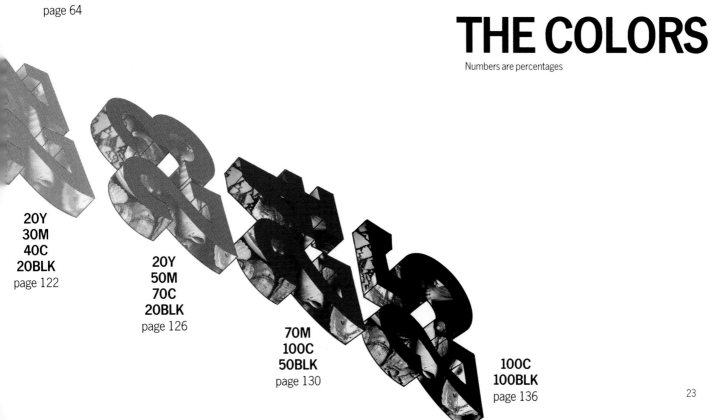

20Y
30M
40C
20BLK
page 122

20Y
50M
70C
20BLK
page 126

70M
100C
50BLK
page 130

100C
100BLK
page 136

COLORS ON TINTS

The 25 main colors are printed on background tints to simulate the effect of printing color on printed stock. This chart can be used in a number of ways: as a guide to see how pale your chosen color can go before it merges with the printed stock; to determine the aesthetic advantages of using a particular color on a specific stock and to experiment with subtle patterns.

The corner flashes (triangles) show the main color in its pure state, while the lettering shows the color printed on the tint.

Green

Blue

Pink

Gray

Cream

	White	10BLK	20BLK	30BLK	40BLK	60BLK	80BLK	100BLK	10Y 20BLK	20Y 20BLK	20Y 40BLK

Numbers are percentages

BLK	10Y 40BLK	10Y 60BLK	10Y 80BLK	10M 30BLK	20Y 30M 20C 10BLK	20M 50BLK	30M 10C 50BLK	30Y 60M 40C 50BLK	10C 40BLK	20Y 30M 40C 20BLK	20Y 50M 70C 20BLK	70M 100C 50BLK	100C 100BLK

25

White

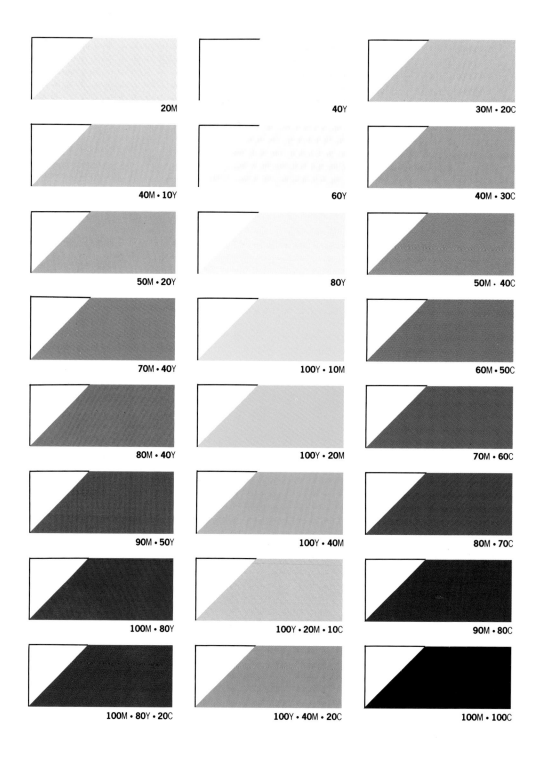

20M

40Y

30M · 20C

40M · 10Y

60Y

40M · 30C

50M · 20Y

80Y

50M · 40C

70M · 40Y

100Y · 10M

60M · 50C

80M · 40Y

100Y · 20M

70M · 60C

90M · 50Y

100Y · 40M

80M · 70C

100M · 80Y

100Y · 20M · 10C

90M · 80C

100M · 80Y · 20C

100Y · 40M · 20C

100M · 100C

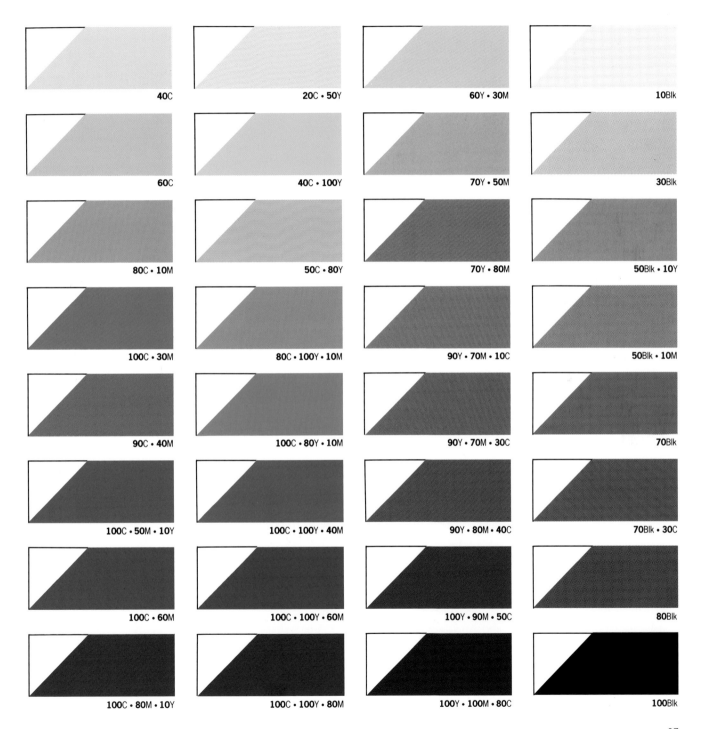

40C

20C • 50Y

60Y • 30M

10Blk

60C

40C • 100Y

70Y • 50M

30Blk

80C • 10M

50C • 80Y

70Y • 80M

50Blk • 10Y

100C • 30M

80C • 100Y • 10M

90Y • 70M • 10C

50Blk • 10M

90C • 40M

100C • 80Y • 10M

90Y • 70M • 30C

70Blk

100C • 50M • 10Y

100C • 100Y • 40M

90Y • 80M • 40C

70Blk • 30C

100C • 60M

100C • 100Y • 60M

100Y • 90M • 50C

80Blk

100C • 80M • 10Y

100C • 100Y • 80M

100Y • 100M • 80C

100Blk

NOTE: For technical information see page 6

Ossidet sterio binignuis tultia, dolorat isogult it gignuntisin stinuand. Flourida prat gereafiunt quaecumque **trutent artsquati, quiateire lurorist de corspore orum** semi uitantque tueri; sol etiam caecat contra osidetsal utiquite

100Blk H/T

Ossidet sterio binignuis tultia, dolorat isogult it gignuntisin stinuand. Flourida prat gereafiunt quaecumque **trutent artsquati, quiateire lurorist de corspore orum** semi uitantque tueri; sol etiam caecat contra osidetsal utiquite

50Blk H/T

30M • 20C • 10Blk 20Y • 40C

10Y • 10C 10M

100Blk 100M

40Y • 40M • 90C • 10Blk 100Y • 90M • 10C

White is where the color story starts. White has elegant, minimalist sophistication. Yet it also represents pure, virginal naivety.

▷ White in the four-color process is obtained by the whiteness of the paper to which the ink is applied. In this subtle design the reason behind the textural pattern of tire tracks is discreetly explained in black type.

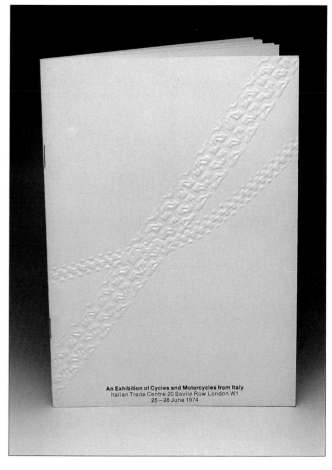

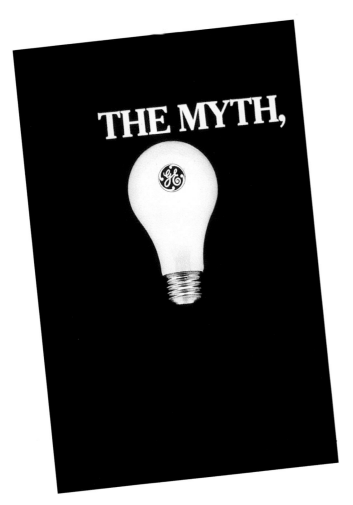

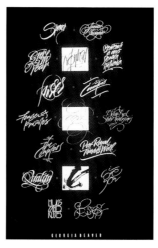

◁ White script stands out from the dense black background, and in doing so appears to float. The white blocks, with black reversed out lettering, create a third dimension and, therefore, the strongest impression. Small dots of red glow in the blackness, breaking the starkness of the black and white.

◁◁ Pure white typography projects to the foreground beyond the minimally tinted off-white image of the lightbulb. The viewer's eye is drawn to the central logo where the contrasting white takes over from the black.

▲ Typography creates the central image through the ingenuity of single color application. The stark simplicity of the white background projects the geometric shape of the contrasting process black "A." However, the white lettering, which appears to be cut out of the black, projects even more strongly, forming a highly visible statement.

▼ White plays the central role on this original and eyecatching book cover. Color reversal has been used to great effect by making the black into a background, allowing white typography and graphics to show through. The contrast is dramatic, with strong visibility.

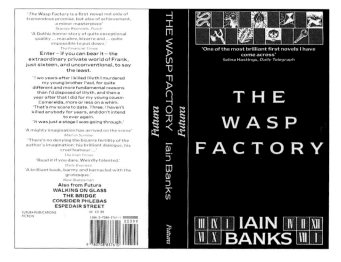

◀ Classic typography and delicate graphics in black on a pure white background create a sophisticated, elegant packaging for designer eyeglasses. The designer's name is softened by the shadowed graphic; this does not detract from the words but frames them.

10Blk

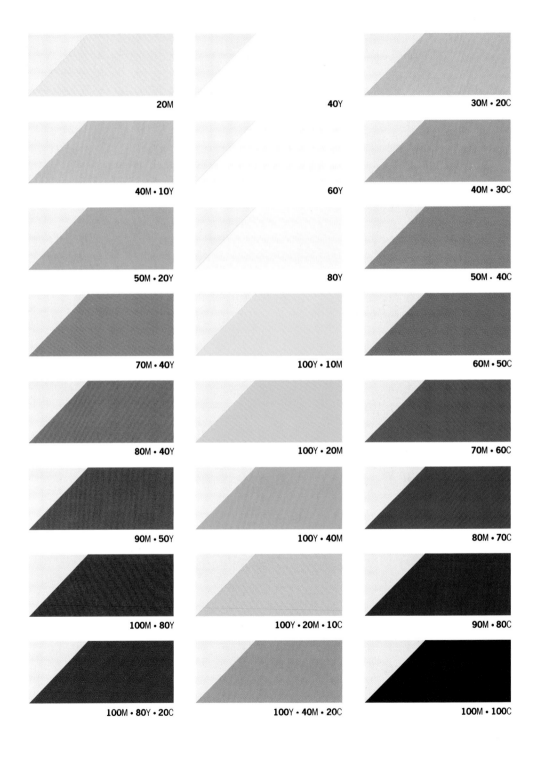

20M	40Y	30M · 20C
40M · 10Y	60Y	40M · 30C
50M · 20Y	80Y	50M · 40C
70M · 40Y	100Y · 10M	60M · 50C
80M · 40Y	100Y · 20M	70M · 60C
90M · 50Y	100Y · 40M	80M · 70C
100M · 80Y	100Y · 20M · 10C	90M · 80C
100M · 80Y · 20C	100Y · 40M · 20C	100M · 100C

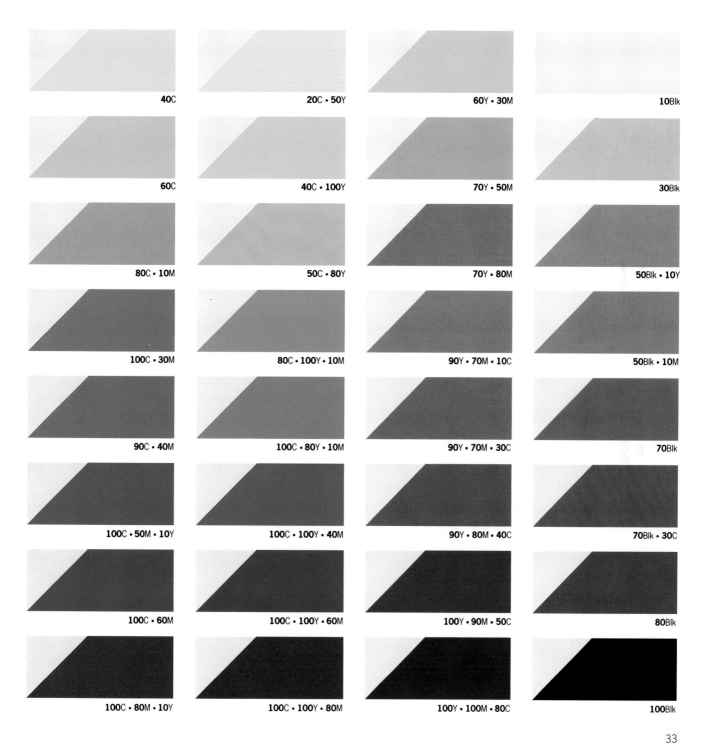

40C	20C • 50Y	60Y • 30M	10Blk
60C	40C • 100Y	70Y • 50M	30Blk
80C • 10M	50C • 80Y	70Y • 80M	50Blk • 10Y
100C • 30M	80C • 100Y • 10M	90Y • 70M • 10C	50Blk • 10M
90C • 40M	100C • 80Y • 10M	90Y • 70M • 30C	70Blk
100C • 50M • 10Y	100C • 100Y • 40M	90Y • 80M • 40C	70Blk • 30C
100C • 60M	100C • 100Y • 60M	100Y • 90M • 50C	80Blk
100C • 80M • 10Y	100C • 100Y • 80M	100Y • 100M • 80C	100Blk

33

NOTE: For technical information see page 6

100
90
80
70
60
50
40
30
20
10
0

100Blk H/T • H/T's: **10**Blk

100Blk H/T • H/T's: **5**Blk

50Blk H/T • H/T's:**10**Blk

50Blk H/T • H/T's: **5**Blk

Ossidet sterio binignuis tultia, dolorat isogult it gignuntisin stinuand. Flourida prat gereafiunt quaecumque **trutent artsquati, quiateire lurorist de corspore orum** semi uitantque tueri; sol etiam caecat contra osidetsal utiquite

100Blk H/T • F/T's: **10**Blk

100Blk H/T • F/T's: **5**Blk

Ossidet sterio binignuis tultia, dolorat isogult it gignuntisin stinuand. Flourida prat gereafiunt quaecumque **trutent artsquati, quiateire lurorist de corspore orum** semi uitantque tueri; sol etiam caecat contra osidetsal utiquite

H/T's: **10**Blk

H/T's: **5**Blk

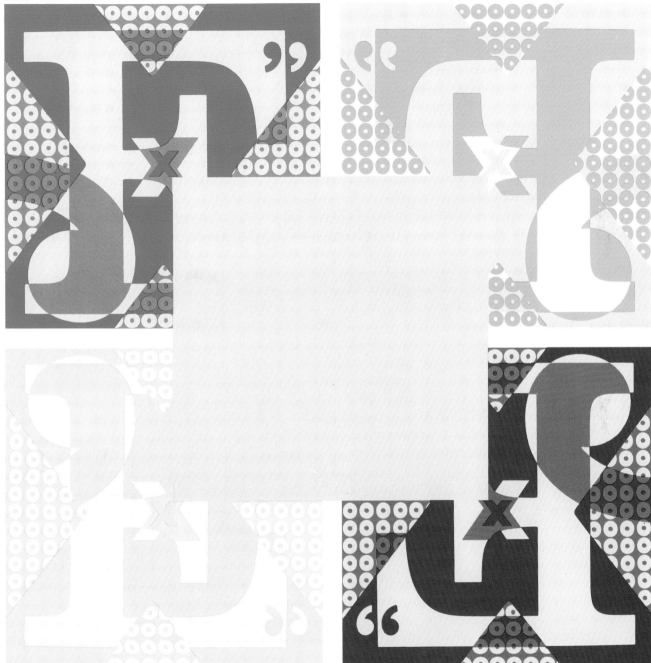

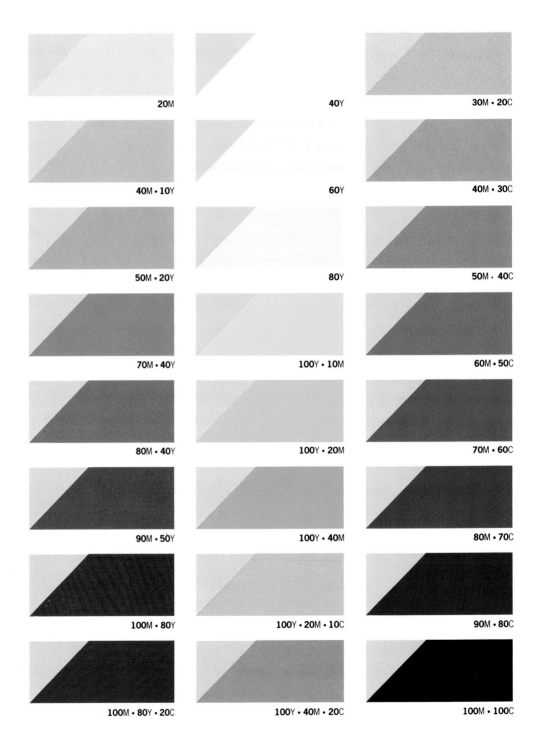

20M

40Y

30M · 20C

40M · 10Y

60Y

40M · 30C

50M · 20Y

80Y

50M · 40C

70M · 40Y

100Y · 10M

60M · 50C

80M · 40Y

100Y · 20M

70M · 60C

90M · 50Y

100Y · 40M

80M · 70C

100M · 80Y

100Y · 20M · 10C

90M · 80C

100M · 80Y · 20C

100Y · 40M · 20C

100M · 100C

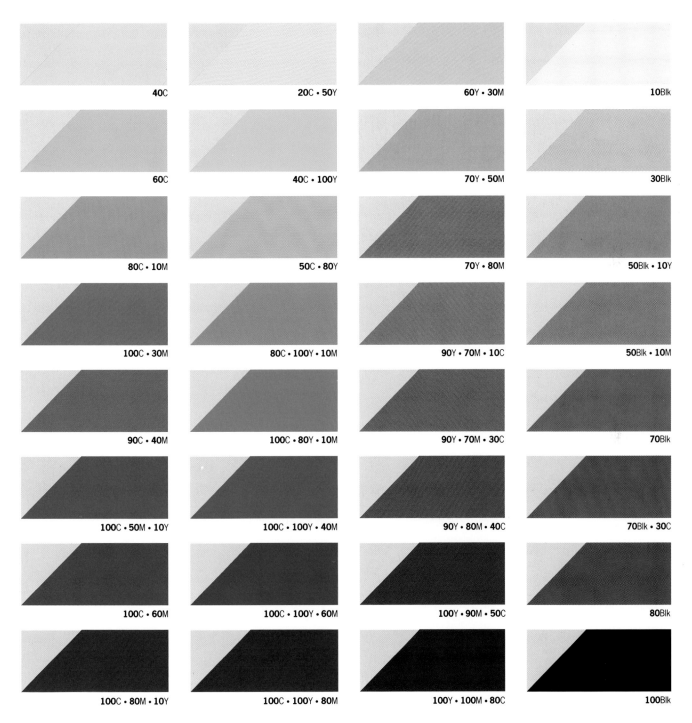

40C	20C • 50Y	60Y • 30M	10Blk
60C	40C • 100Y	70Y • 50M	30Blk
80C • 10M	50C • 80Y	70Y • 80M	50Blk • 10Y
100C • 30M	80C • 100Y • 10M	90Y • 70M • 10C	50Blk • 10M
90C • 40M	100C • 80Y • 10M	90Y • 70M • 30C	70Blk
100C • 50M • 10Y	100C • 100Y • 40M	90Y • 80M • 40C	70Blk • 30C
100C • 60M	100C • 100Y • 60M	100Y • 90M • 50C	80Blk
100C • 80M • 10Y	100C • 100Y • 80M	100Y • 100M • 80C	100Blk

20Blk

NOTE: For technical information see page 6

100

90

80

Ossidet sterio binignuis tultia, dolorat isogult it gignuntisin stinuand. Flourida prat gereafiunt quaecumque trutent artsquati, quiateire lurorist de corspore orum semi uitantque tueri; sol etiam caecat contra osidetsal utiquite

100Blk H/T • H/T's: **20**Blk **100**Blk H/T • H/T's: **10**Blk

70

60

Ossidet sterio binignuis tultia, dolorat isogult it gignuntisin stinuand. Flourida prat gereafiunt quaecumque trutent artsquati, quiateire lurorist de corspore orum semi uitantque tueri; sol etiam caecat contra osidetsal utiquite

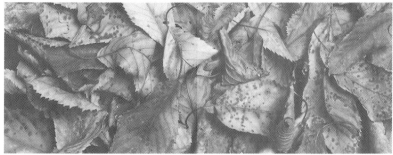

50Blk H/T • H/T's: **20**Blk **50**Blk H/T • H/T's: **10**Blk

50

40

30

Ossidet sterio binignuis tultia, dolorat isogult it gignuntisin stinuand. Flourida prat gereafiunt quaecumque trutent artsquati, quiateire lurorist de corspore orum semi uitantque tueri; sol etiam caecat contra osidetsal utiquite

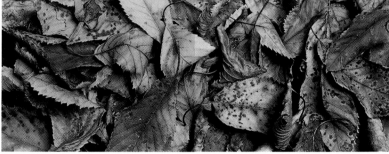

100Blk H/T • F/T's: **20**Blk **100**Blk H/T • F/T's: **10**Blk

20

10

0

Ossidet sterio binignuis tultia, dolorat isogult it gignuntisin stinuand. Flourida prat gereafiunt quaecumque trutent artsquati, quiateire lurorist de corspore orum semi uitantque tueri; sol etiam caecat contra osidetsal utiquite

H/T's: **20**Blk H/T's: **10**Blk

30Blk

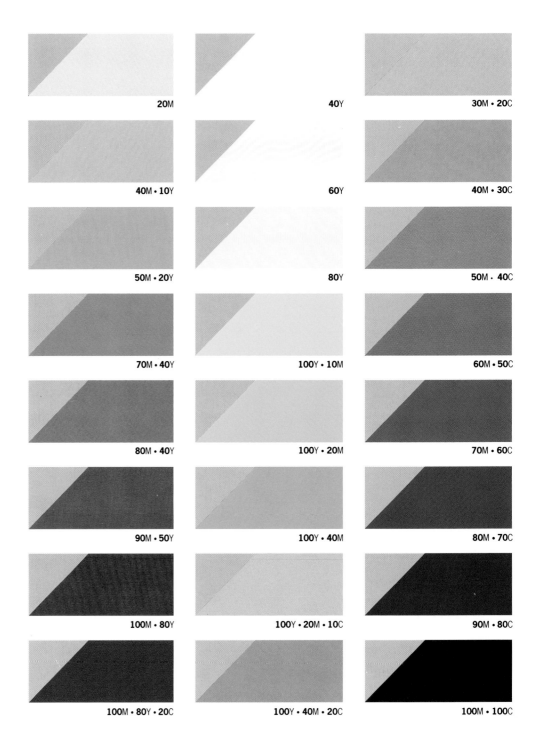

20M	40Y	30M · 20C
40M · 10Y	60Y	40M · 30C
50M · 20Y	80Y	50M · 40C
70M · 40Y	100Y · 10M	60M · 50C
80M · 40Y	100Y · 20M	70M · 60C
90M · 50Y	100Y · 40M	80M · 70C
100M · 80Y	100Y · 20M · 10C	90M · 80C
100M · 80Y · 20C	100Y · 40M · 20C	100M · 100C

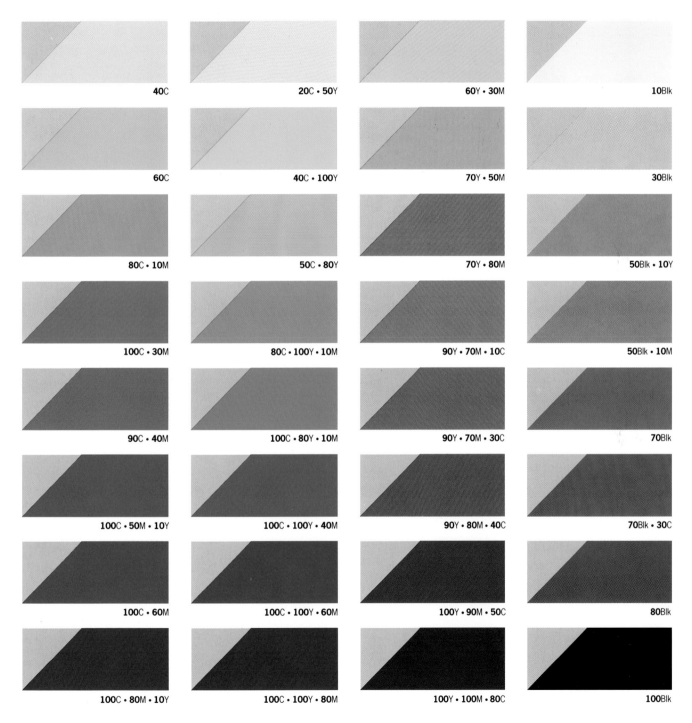

40C	20C · 50Y	60Y · 30M	10Blk
60C	40C · 100Y	70Y · 50M	30Blk
80C · 10M	50C · 80Y	70Y · 80M	50Blk · 10Y
100C · 30M	80C · 100Y · 10M	90Y · 70M · 10C	50Blk · 10M
90C · 40M	100C · 80Y · 10M	90Y · 70M · 30C	70Blk
100C · 50M · 10Y	100C · 100Y · 40M	90Y · 80M · 40C	70Blk · 30C
100C · 60M	100C · 100Y · 60M	100Y · 90M · 50C	80Blk
100C · 80M · 10Y	100C · 100Y · 80M	100Y · 100M · 80C	100Blk

30Blk

100

90

80

70

60

50

40

30

20

10

0

**Ossidet sterio binignuis
tultia, dolorat isogult it**
gignuntisin stinuand. Flourida
prat gereafiunt quaecumque
**trutent artsquati, quiateire
lurorist de corspore orum**
semi uitantque tueri; sol etiam
caecat contra osidetsal utiquite

Ossidet sterio binignuis
tultia, dolorat isogult it
gignuntisin stinuand. Flourida
prat gereafiunt quaecumque
trutent artsquati, quiateire
lurorist de corspore orum
semi uitantque tueri; sol etiam
caecat contra osidetsal utiquite

Ossidet sterio binignuis
tultia, dolorat isogult it
gignuntisin stinuand. Flourida
prat gereafiunt quaecumque
**trutent artsquati, quiateire
lurorist de corspore orum**
semi uitantque tueri; sol etiam
caecat contra osidetsal utiquite

Ossidet sterio binignuis
tultia, dolorat isogult it
gignuntisin stinuand. Flourida
prat gereafiunt quaecumque
**trutent artsquati, quiateire
lurorist de corspore orum**
semi uitantque tueri; sol etiam
caecat contra osidetsal utiquite

NOTE: For technical information see page 6

100Blk H/T • H/T's: **30**Blk **100**Blk H/T • H/T's: **15**Blk

50Blk H/T • H/T's: **30**Blk **50**Blk H/T • H/T's: **15**Blk

100Blk H/T • F/T's: **30**Blk **100**Blk H/T • F/T's: **15**Blk

H/T's: **30**Blk H/T's: **15**Blk

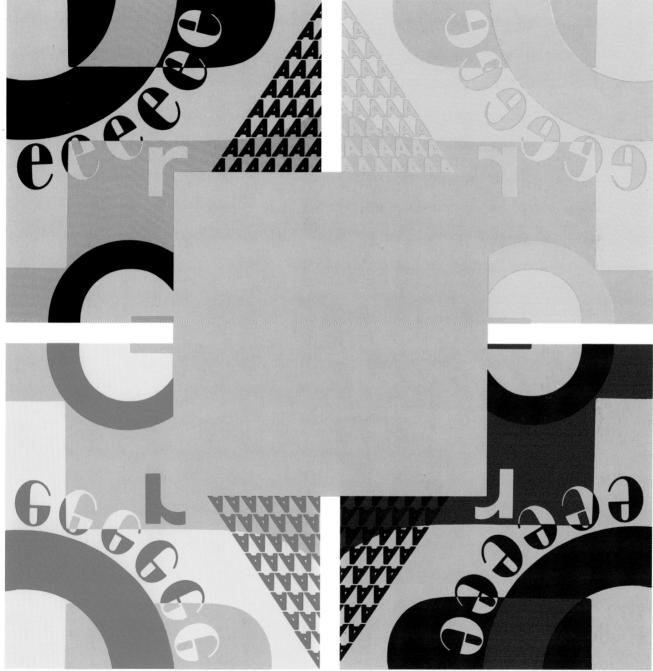

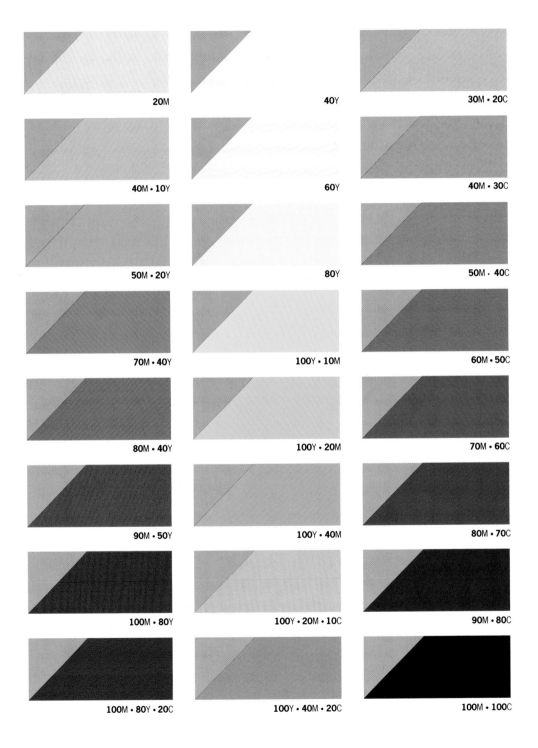

20M

40Y

30M · 20C

40M · 10Y

60Y

40M · 30C

50M · 20Y

80Y

50M · 40C

70M · 40Y

100Y · 10M

60M · 50C

80M · 40Y

100Y · 20M

70M · 60C

90M · 50Y

100Y · 40M

80M · 70C

100M · 80Y

100Y · 20M · 10C

90M · 80C

100M · 80Y · 20C

100Y · 40M · 20C

100M · 100C

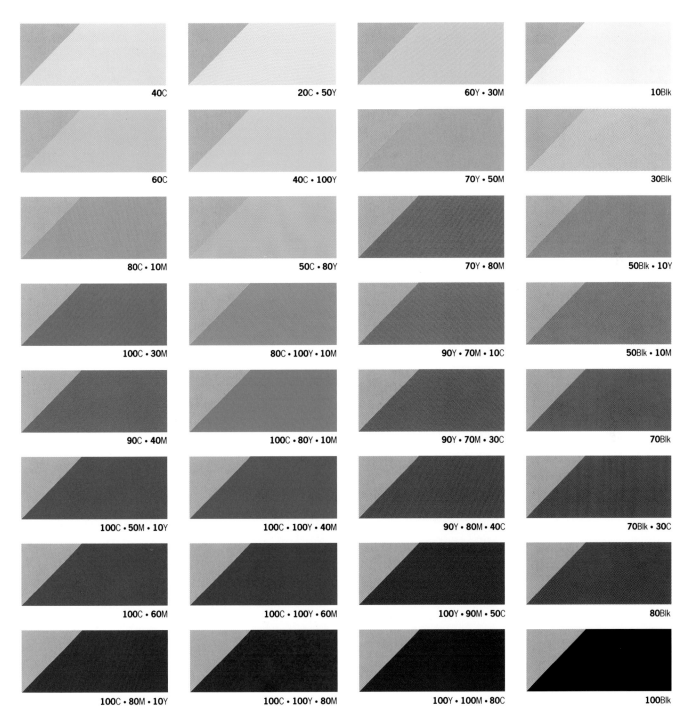

40C	20C • 50Y	60Y • 30M	10Blk
60C	40C • 100Y	70Y • 50M	30Blk
80C • 10M	50C • 80Y	70Y • 80M	50Blk • 10Y
100C • 30M	80C • 100Y • 10M	90Y • 70M • 10C	50Blk • 10M
90C • 40M	100C • 80Y • 10M	90Y • 70M • 30C	70Blk
100C • 50M • 10Y	100C • 100Y • 40M	90Y • 80M • 40C	70Blk • 30C
100C • 60M	100C • 100Y • 60M	100Y • 90M • 50C	80Blk
100C • 80M • 10Y	100C • 100Y • 80M	100Y • 100M • 80C	100Blk

NOTE: For technical information see page 6

100
90
80

Ossidet sterio binignuis tultia, dolorat isogult it gignuntisin stinuand. Flourida prat gereafiunt quaecumque **trutent artsquati, quiateire lurorist de corspore orum** semi uitantque tueri; sol etiam caecat contra osidetsal utiquite

100Blk H/T • H/T's: **40**Blk **100**Blk H/T • H/T's: **20**Blk

70
60
50

Ossidet sterio binignuis tultia, dolorat isogult it gignuntisin stinuand. Flourida prat gereafiunt quaecumque trutent artsquati, quiateire lurorist de corspore orum semi uitantque tueri; sol etiam caecat contra osidetsal utiquite

50Blk H/T • H/T's: **40**Blk **50**Blk H/T • H/T's: **20**Blk

40
30

Ossidet sterio binignuis tultia, dolorat isogult it gignuntisin stinuand. Flourida prat gereafiunt quaecumque **trutent artsquati, quiateire lurorist de corspore orum** semi uitantque tueri; sol etiam caecat contra osidetsal utiquite

100Blk H/T • F/T's: **40**Blk **100**Blk H/T • F/T's: **20**Blk

20
10
0

Ossidet sterio binignuis tultia, dolorat isogult it gignuntisin stinuand. Flourida prat gereafiunt quaecumque **trutent artsquati, quiateire lurorist de corspore orum** semi uitantque tueri; sol etiam caecat contra osidetsal utiquite

H/T's: **40**Blk H/T's: **20**Blk

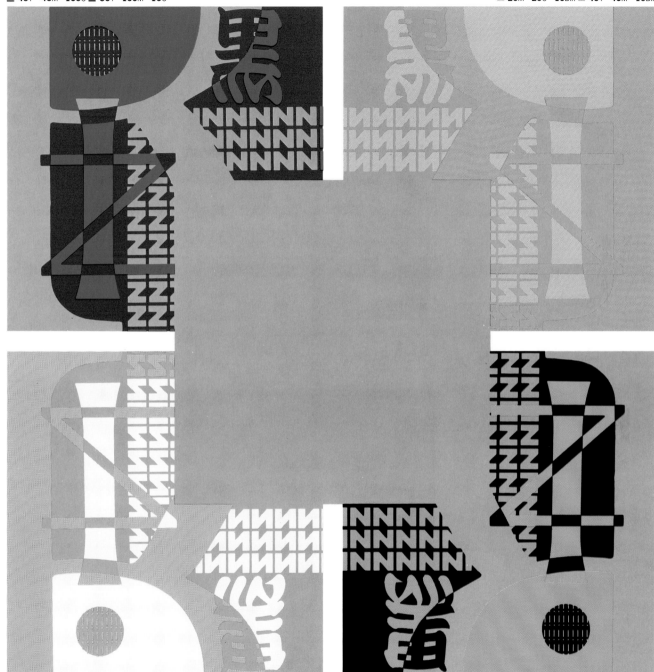

■ 40Y・40M・100C ■ 50Y・100M・10C

▨ 20M・20C・10Blk ▨ 40Y・40M・10Blk

10C ▨ 30C・20Blk

■ 50Y・50C・10Blk ■ 30Y・100M・100C・40Blk

Percentages of black create true gray – anonymous, tonal and receptive. These are the shades of backgrounds and shadows.

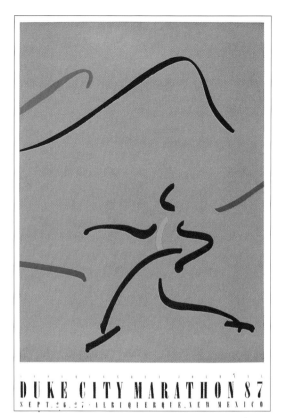

◢ Gray provides a warm, anonymous background which sympathetically projects the fluid movement of the brightly colored graphics. The white border and title banner make the gray recede, giving a sense of depth.

▼ The quiet anonymity of dove gray is brightened by white typography. The design acquires depth and interest with the addition of a black checkerboard edge, while the humorous soft black graphics harmonize with the dove gray.

▲ A range of gray tones combine to form a richly textured image. The tonal grays in this monochrome illustration are interestingly atmospheric, and create an illusion of depth that would normally be associated with color.

The soft gray handblock graphic of an ant creates a surreal image as it appears to float on the white paper. This image has impact because of its isolation on the white background, while the gentle shade is suitable for writing paper.

Silver gray combines with blue to reflect an image of ice-cold quality. The use of black and white for the logo strengthens the design, while the contrast retains the coldness of the gray.

The color spectrum is given luminosity by the softness of the mole-gray background. Harsh white is used to project the type and graphics from the gentle gray, giving them strength and clarity.

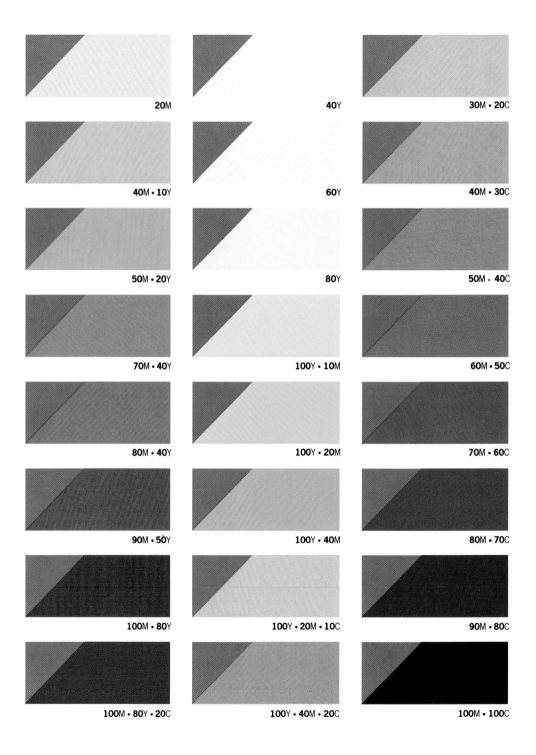

20M

40Y

30M · 20C

40M · 10Y

60Y

40M · 30C

50M · 20Y

80Y

50M · 40C

70M · 40Y

100Y · 10M

60M · 50C

80M · 40Y

100Y · 20M

70M · 60C

90M · 50Y

100Y · 40M

80M · 70C

100M · 80Y

100Y · 20M · 10C

90M · 80C

100M · 80Y · 20C

100Y · 40M · 20C

100M · 100C

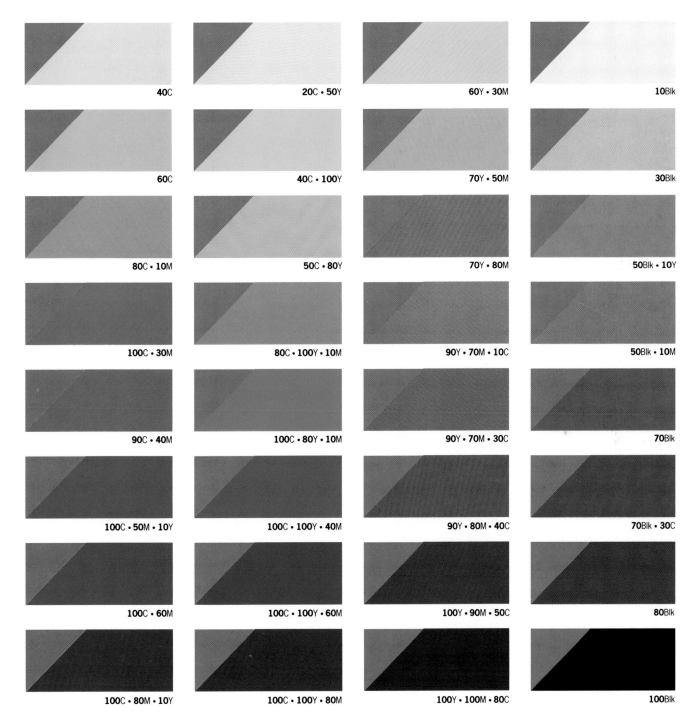

40C

20C • 50Y

60Y • 30M

10Blk

60C

40C • 100Y

70Y • 50M

30Blk

80C • 10M

50C • 80Y

70Y • 80M

50Blk • 10Y

100C • 30M

80C • 100Y • 10M

90Y • 70M • 10C

50Blk • 10M

90C • 40M

100C • 80Y • 10M

90Y • 70M • 30C

70Blk

100C • 50M • 10Y

100C • 100Y • 40M

90Y • 80M • 40C

70Blk • 30C

100C • 60M

100C • 100Y • 60M

100Y • 90M • 50C

80Blk

100C • 80M • 10Y

100C • 100Y • 80M

100Y • 100M • 80C

100Blk

NOTE: For technical information see page 6

100

90

Ossidet sterio binignuis tultia, dolorat isogult it gignuntisin stinuand. Flourida prat gereafiunt quaecumque **trutent artsquati, quiateire lurorist de corspore orum** semi uitantque tueri; sol etiam caecat contra osidetsal utiquite

100Blk H/T • H/T's: **60**Blk 100Blk H/T • H/T's: **30**Blk

80

70

Ossidet sterio binignuis tultia, dolorat isogult it gignuntisin stinuand. Flourida prat gereafiunt quaecumque trutent artsquati, quiateire lurorist de corspore orum semi uitantque tueri; sol etiam caecat contra osidetsal utiquite

50Blk H/T • H/T's: **60**Blk 50Blk H/T • H/T's: **30**Blk

60

50

Ossidet sterio binignuis tultia, dolorat isogult it gignuntisin stinuand. Flourida prat gereafiunt quaecumque **trutent artsquati, quiateire lurorist de corspore orum** semi uitantque tueri; sol etiam caecat contra osidetsal utiquite

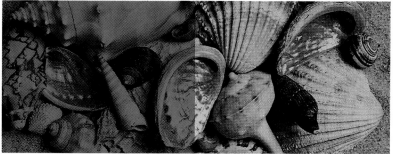

100Blk H/T • F/T's: **60**Blk 100Blk H/T • F/T's: **30**Blk

40

30

20

Ossidet sterio binignuis tultia, dolorat isogult it gignuntisin stinuand. Flourida prat gereafiunt quaecumque **trutent artsquati, quiateire lurorist de corspore orum** semi uitantque tueri; sol etiam caecat contra osidetsal utiquite

H/T's: **60**Blk H/T's: **30**Blk

10

0

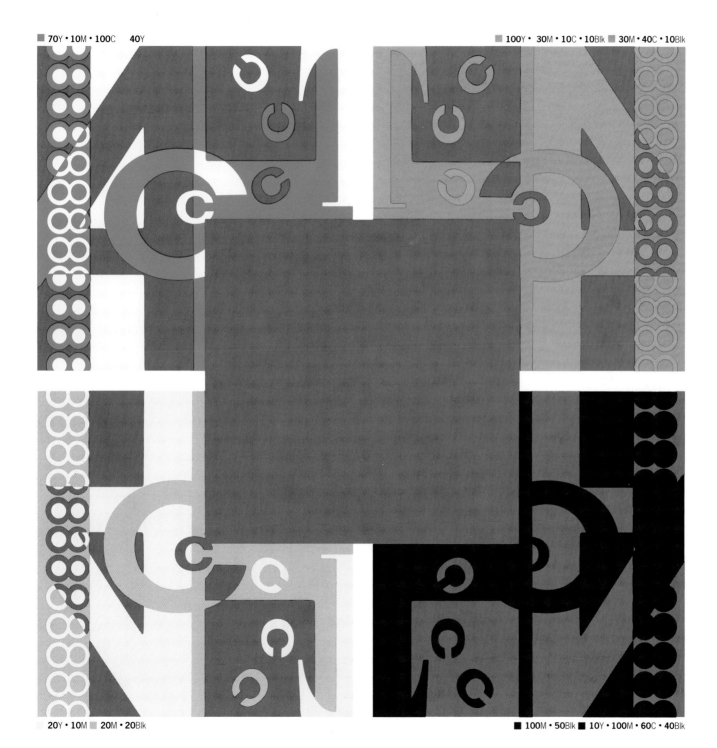

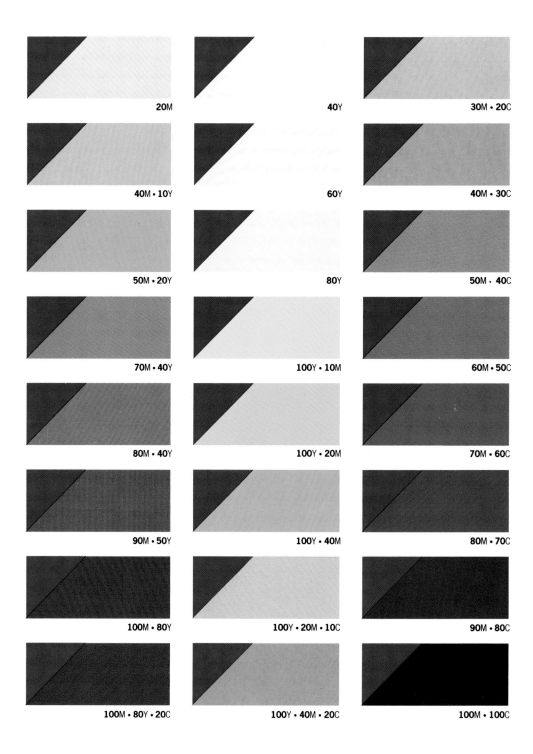

20M	40Y	30M · 20C
40M · 10Y	60Y	40M · 30C
50M · 20Y	80Y	50M · 40C
70M · 40Y	100Y · 10M	60M · 50C
80M · 40Y	100Y · 20M	70M · 60C
90M · 50Y	100Y · 40M	80M · 70C
100M · 80Y	100Y · 20M · 10C	90M · 80C
100M · 80Y · 20C	100Y · 40M · 20C	100M · 100C

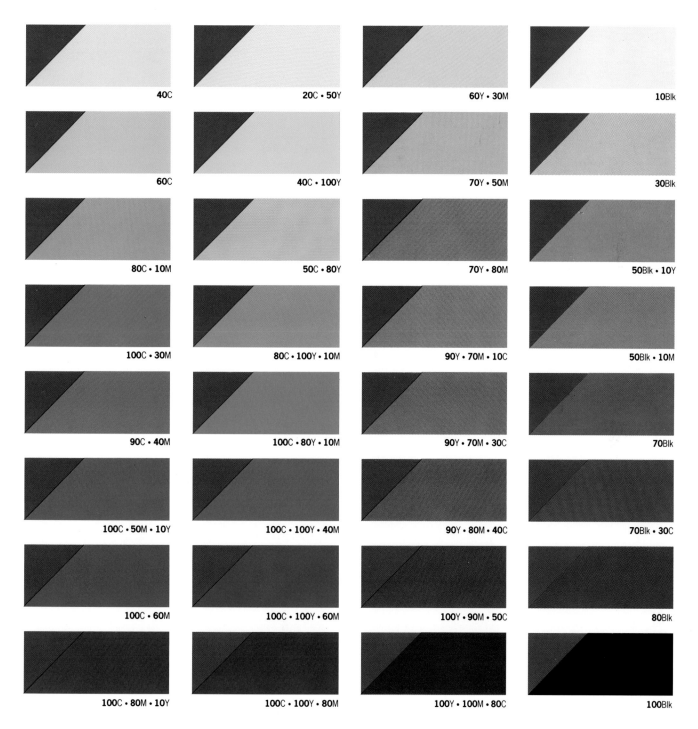

40C

20C • 50Y

60Y • 30M

10Blk

60C

40C • 100Y

70Y • 50M

30Blk

80C • 10M

50C • 80Y

70Y • 80M

50Blk • 10Y

100C • 30M

80C • 100Y • 10M

90Y • 70M • 10C

50Blk • 10M

90C • 40M

100C • 80Y • 10M

90Y • 70M • 30C

70Blk

100C • 50M • 10Y

100C • 100Y • 40M

90Y • 80M • 40C

70Blk • 30C

100C • 60M

100C • 100Y • 60M

100Y • 90M • 50C

80Blk

100C • 80M • 10Y

100C • 100Y • 80M

100Y • 100M • 80C

100Blk

55

NOTE: For technical information see page 6

100

90

80

70

60

50

40

30

20

10

0

Ossidet sterio binignuis tultia, dolorat isogult it gignuntisin stinuand. Flourida prat gereafiunt quaecumque trutent artsquati, quiateire lurorist de corspore orum semi uitantque tueri; sol etiam caecat contra osidetsal utiquite

Ossidet sterio binignuis tultia, dolorat isogult it gignuntisin stinuand. Flourida prat gereafiunt quaecumque trutent artsquati, quiateire lurorist de corspore orum semi uitantque tueri; sol etiam caecat contra osidetsal utiquite

Ossidet sterio binignuis tultia, dolorat isogult it gignuntisin stinuand. Flourida prat gereafiunt quaecumque trutent artsquati, quiateire lurorist de corspore orum semi uitantque tueri; sol etiam caecat contra osidetsal utiquite

Ossidet sterio binignuis tultia, dolorat isogult it gignuntisin stinuand. Flourida prat gereafiunt quaecumque trutent artsquati, quiateire lurorist de corspore orum semi uitantque tueri; sol etiam caecat contra osidetsal utiquite

100Blk H/T • H/T's: **80**Blk 100Blk H/T • H/T's: **40**Blk

50Blk H/T • H/T's: **80**Blk 50Blk H/T • H/T's: **40**Blk

100Blk H/T • F/T's: **80**Blk 100Blk H/T • F/T's: **40**Blk

H/T's: **80**Blk H/T's: **40**Blk

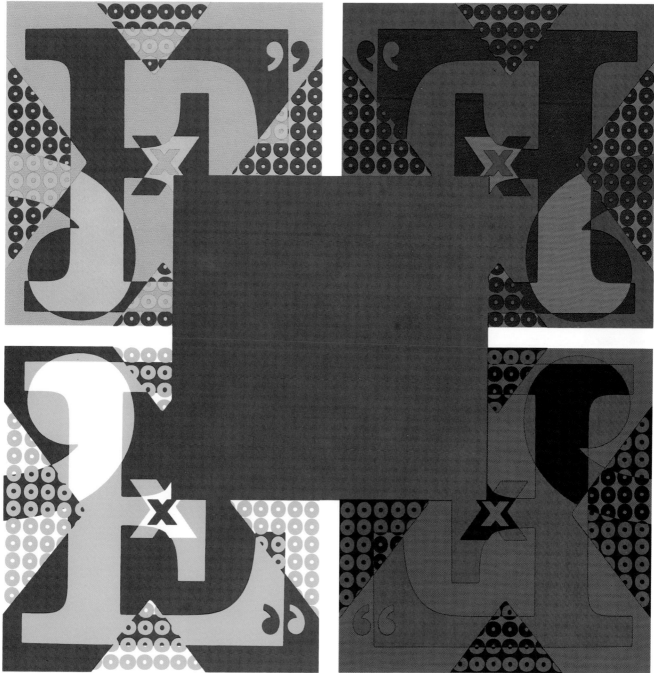

100Blk

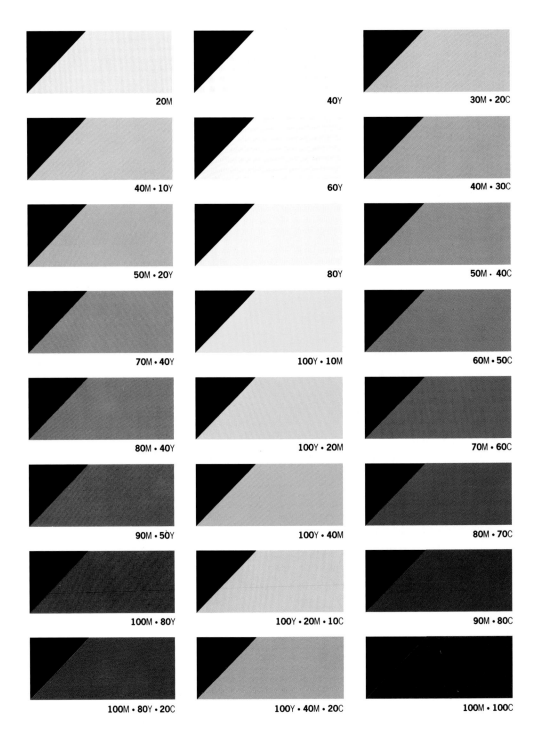

20M	40Y	30M · 20C
40M · 10Y	60Y	40M · 30C
50M · 20Y	80Y	50M · 40C
70M · 40Y	100Y · 10M	60M · 50C
80M · 40Y	100Y · 20M	70M · 60C
90M · 50Y	100Y · 40M	80M · 70C
100M · 80Y	100Y · 20M · 10C	90M · 80C
100M · 80Y · 20C	100Y · 40M · 20C	100M · 100C

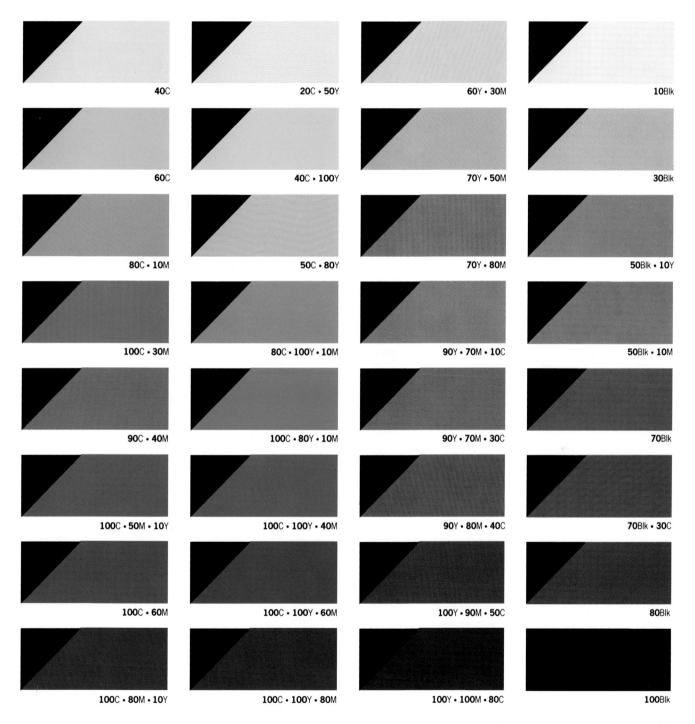

40C	20C • 50Y	60Y • 30M	10Blk
60C	40C • 100Y	70Y • 50M	30Blk
80C • 10M	50C • 80Y	70Y • 80M	50Blk • 10Y
100C • 30M	80C • 100Y • 10M	90Y • 70M • 10C	50Blk • 10M
90C • 40M	100C • 80Y • 10M	90Y • 70M • 30C	70Blk
100C • 50M • 10Y	100C • 100Y • 40M	90Y • 80M • 40C	70Blk • 30C
100C • 60M	100C • 100Y • 60M	100Y • 90M • 50C	80Blk
100C • 80M • 10Y	100C • 100Y • 80M	100Y • 100M • 80C	100Blk

100Blk

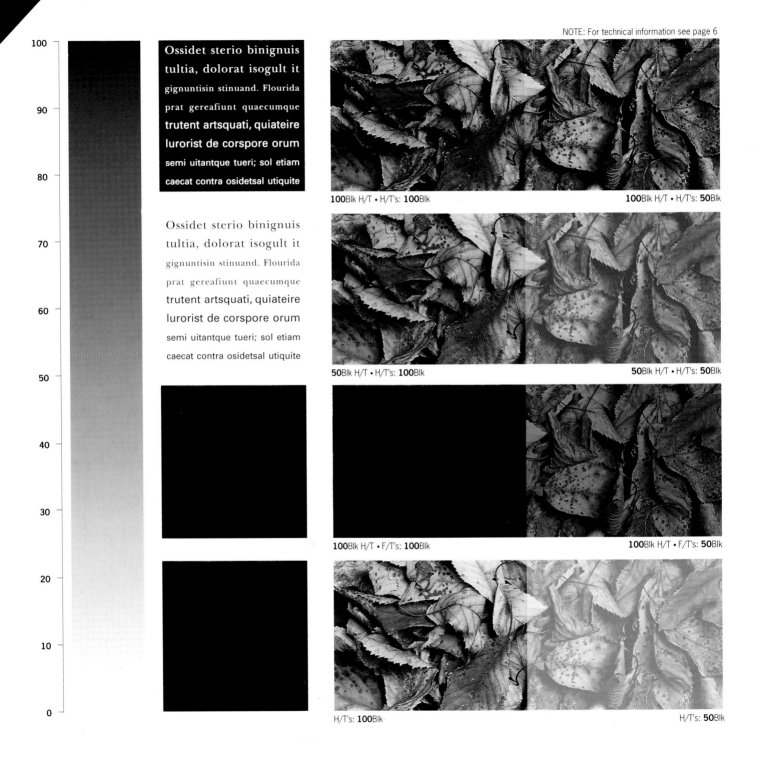

NOTE: For technical information see page 6

Ossidet sterio binignuis tultia, dolorat isogult it gignuntisin stinuand. Flourida prat gereafiunt quaecumque **trutent artsquati, quiateire lurorist de corspore orum** semi uitantque tueri; sol etiam caecat contra osidetsal utiquite

Ossidet sterio binignuis tultia, dolorat isogult it gignuntisin stinuand. Flourida prat gereafiunt quaecumque trutent artsquati, quiateire lurorist de corspore orum semi uitantque tueri; sol etiam caecat contra osidetsal utiquite

100Blk H/T • H/T's: **100**Blk

100Blk H/T • H/T's: **50**Blk

50Blk H/T • H/T's: **100**Blk

50Blk H/T • H/T's: **50**Blk

100Blk H/T • F/T's: **100**Blk

100Blk H/T • F/T's: **50**Blk

H/T's: **100**Blk

H/T's: **50**Blk

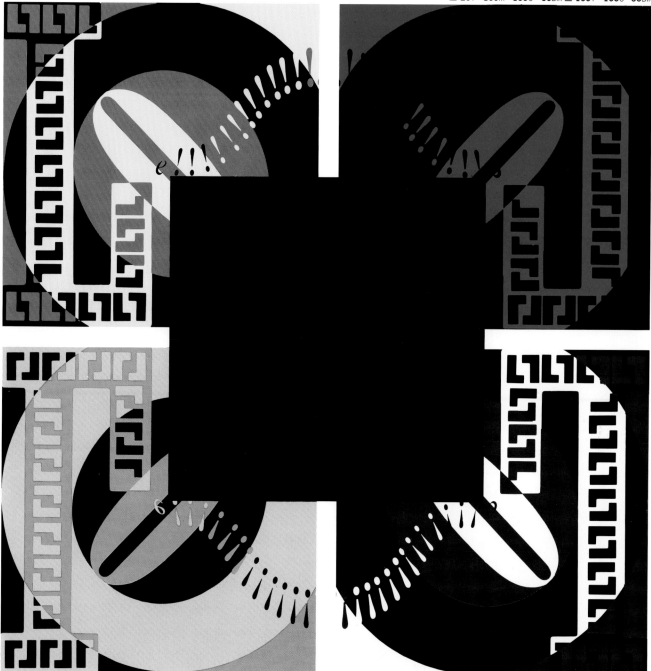

*Graphite and charcoal
are logical and dignified.
They provide contrast
and definition,
atmosphere and
strength.*

▼ The claustrophobic atmosphere of
the photographic negative is
recreated by applying a medium-gray
on black. The agony conveyed in this
effective illustration is strengthened
by the use of pure white for the text,
in contrast with the black background.

◄ An original choice of color with
minimal graphics has created a
memorable book cover. The
contrasting stone gray background
gives visibility and clarity to the white
calligraphy. Buttercup yellow
harmonizes with the gray but reacts
against the sky-blue, while the gray is
sympathetic to this pastel shade.

▼ Graphite gray reinforces the
strength of the block print. The clear
white type with the white and black
logo are given depth and atmosphere
by the touches of graphite within the
white type of the product name.

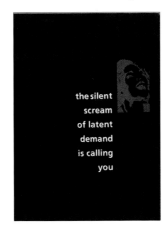

the silent
scream
of latent
demand
is calling
you

▼ A gentle medium gray has been
used in this minimalist approach to
color and typography. The softness of
the gray typography allows the natural
brightness of the peppers to project,
while being easy to read.

ESSEN TIALS

This section takes a detailed look at
the basic raw ingredients that will
combine succ essfully to make up a
salad and shows how to add glamour to your
salads using garnishes.

SOOTHING AND HEALING
AFTER SHAVE
BALM
SG
150 ml 5·1 fl oz

The WOLFF OLINS GUIDE to CORPORATE IDENTITY

Colors provide the action and the content of this saying. The black typography is hidden among the deep tones of the carbon gray background. In total contrast, bright white type lights up the image. The carbon has manipulated these opposite shades into performing a practical function with strength and purpose.

Rather than curse the darkness light a candle

The simulation of a telex printout for the logo of the international news agency is highly appropriate. The choice of slate gray rather than black provides a subtle contrast and warmth of definition.

Pearl gray brings dignity and stability to an unorthodox color palette. The soft gray both contrasts and harmonizes with the warm rose background, while forming a backdrop for the black and white typography. Despite the romantic nature of the rose color, this harmonious combination conveys a sense of authority and confidence.

63

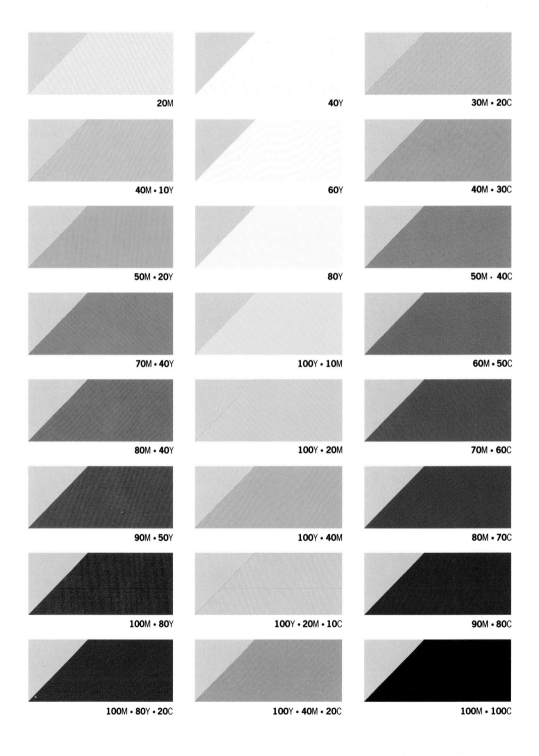

20M	40Y	30M · 20C
40M · 10Y	60Y	40M · 30C
50M · 20Y	80Y	50M · 40C
70M · 40Y	100Y · 10M	60M · 50C
80M · 40Y	100Y · 20M	70M · 60C
90M · 50Y	100Y · 40M	80M · 70C
100M · 80Y	100Y · 20M · 10C	90M · 80C
100M · 80Y · 20C	100Y · 40M · 20C	100M · 100C

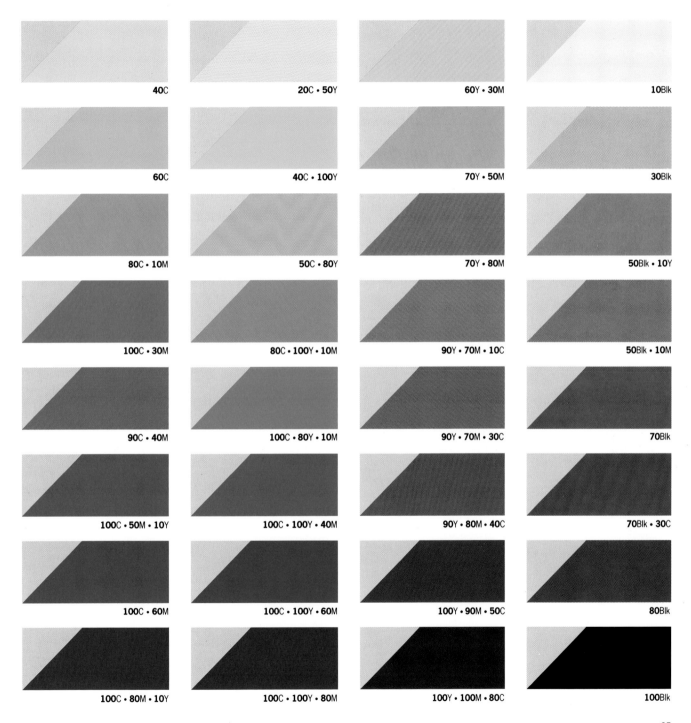

40C	20C • 50Y	60Y • 30M	10Blk
60C	40C • 100Y	70Y • 50M	30Blk
80C • 10M	50C • 80Y	70Y • 80M	50Blk • 10Y
100C • 30M	80C • 100Y • 10M	90Y • 70M • 10C	50Blk • 10M
90C • 40M	100C • 80Y • 10M	90Y • 70M • 30C	70Blk
100C • 50M • 10Y	100C • 100Y • 40M	90Y • 80M • 40C	70Blk • 30C
100C • 60M	100C • 100Y • 60M	100Y • 90M • 50C	80Blk
100C • 80M • 10Y	100C • 100Y • 80M	100Y • 100M • 80C	100Blk

NOTE: For technical information see page 6

Ossidet sterio binignuis tultia, dolorat isogult it gignuntisin stinuand. Flourida prat gereafiunt quaecumque trutent artsquati, quiateire lurorist de corspore orum semi uitantque tueri; sol etiam caecat contra osidetsal utiquite

Ossidet sterio binignuis tultia, dolorat isogult it gignuntisin stinuand. Flourida prat gereafiunt quaecumque trutent artsquati, quiateire lurorist de corspore orum semi uitantque tueri; sol etiam caecat contra osidetsal utiquite

Ossidet sterio binignuis tultia, dolorat isogult it gignuntisin stinuand. Flourida prat gereafiunt quaecumque trutent artsquati, quiateire lurorist de corspore orum semi uitantque tueri; sol etiam caecat contra osidetsal utiquite

Ossidet sterio binignuis tultia, dolorat isogult it gignuntisin stinuand. Flourida prat gereafiunt quaecumque trutent artsquati, quiateire lurorist de corspore orum semi uitantque tueri; sol etiam caecat contra osidetsal utiquite

100Blk H/T • H/T's: **10**Y • **20**Blk

100Blk H/T • H/T's: **5**Y • **10**Blk

50Blk H/T • H/T's: **10**Y • **20**Blk

50Blk H/T • H/T's: **5**Y • **10**Blk

100Blk H/T • F/T's: **10**Y • **20**Blk

100Blk H/T • F/T's: **5**Y • **10**Blk

H/T's: **10**Y • **20**Blk

H/T's: **5**Y • **10**Blk

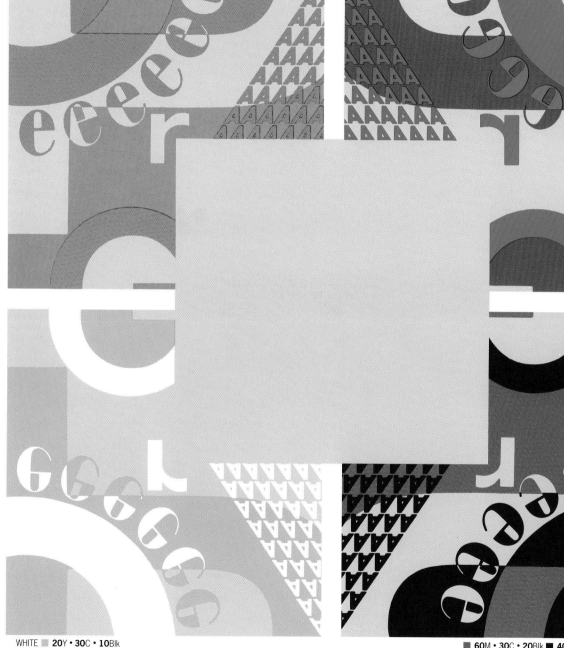

20Y·20Blk

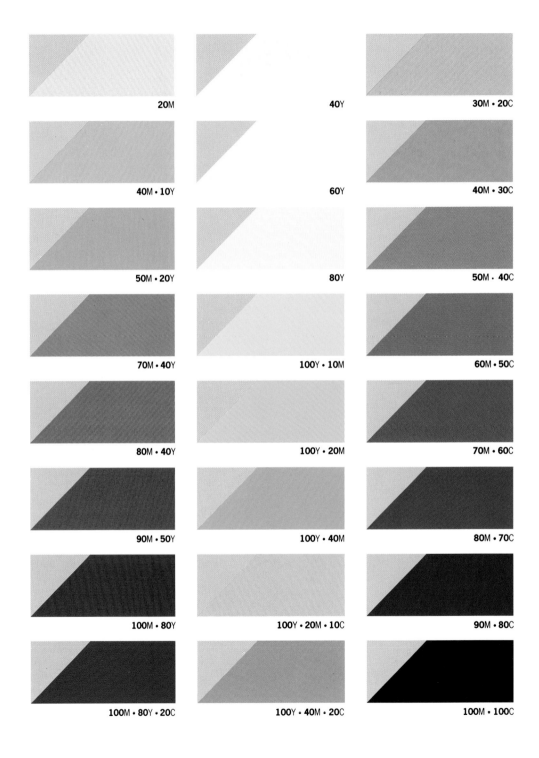

20M

40Y

30M·20C

40M·10Y

60Y

40M·30C

50M·20Y

80Y

50M·40C

70M·40Y

100Y·10M

60M·50C

80M·40Y

100Y·20M

70M·60C

90M·50Y

100Y·40M

80M·70C

100M·80Y

100Y·20M·10C

90M·80C

100M·80Y·20C

100Y·40M·20C

100M·100C

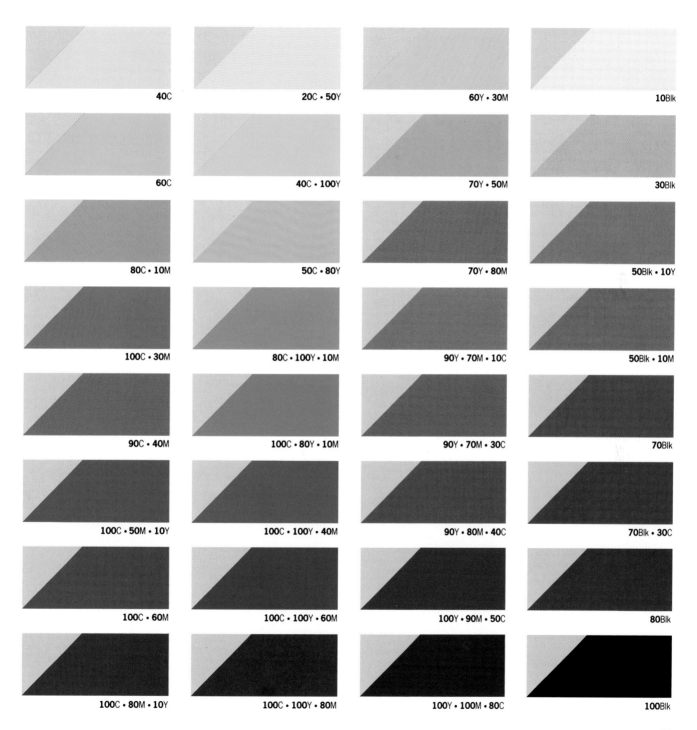

40C	20C • 50Y	60Y • 30M	10Blk
60C	40C • 100Y	70Y • 50M	30Blk
80C • 10M	50C • 80Y	70Y • 80M	50Blk • 10Y
100C • 30M	80C • 100Y • 10M	90Y • 70M • 10C	50Blk • 10M
90C • 40M	100C • 80Y • 10M	90Y • 70M • 30C	70Blk
100C • 50M • 10Y	100C • 100Y • 40M	90Y • 80M • 40C	70Blk • 30C
100C • 60M	100C • 100Y • 60M	100Y • 90M • 50C	80Blk
100C • 80M • 10Y	100C • 100Y • 80M	100Y • 100M • 80C	100Blk

20Y · 20Blk

NOTE: For technical information see page 6

100

90

80

Ossidet sterio binignuis
tultia, dolorat isogult it
gignuntisin stinuand. Flourida
prat gereafiunt quaecumque
trutent artsquati, quiateire
lurorist de corspore orum
semi uitantque tueri; sol etiam
caecat contra osidetsal utiquite

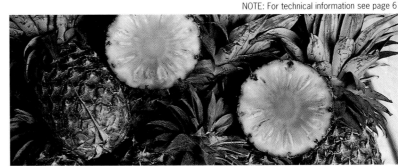

100Blk H/T • H/T's: **20**Y • **20**Blk 100Blk H/T • H/T's: **10**Y • **10**Blk

70

60

50

Ossidet sterio binignuis
tultia, dolorat isogult it
gignuntisin stinuand. Flourida
prat gereafiunt quaecumque
trutent artsquati, quiateire
lurorist de corspore orum
semi uitantque tueri; sol etiam
caecat contra osidetsal utiquite

50Blk H/T • H/T's: **20**Y • **20**Blk 50Blk H/T • H/T's: **10**Y • **10**Blk

40

30

Ossidet sterio binignuis
tultia, dolorat isogult it
gignuntisin stinuand. Flourida
prat gereafiunt quaecumque
trutent artsquati, quiateire
lurorist de corspore orum
semi uitantque tueri; sol etiam
caecat contra osidetsal utiquite

100Blk H/T • F/T's: **20**Y • **20**Blk 100Blk H/T • F/T's: **10**Y • **10**Blk

20

10

0

Ossidet sterio binignuis
tultia, dolorat isogult it
gignuntisin stinuand. Flourida
prat gereafiunt quaecumque
trutent artsquati, quiateire
lurorist de corspore orum
semi uitantque tueri; sol etiam
caecat contra osidetsal utiquite

H/T's: **20**Y • **20**Blk H/T's: **10**Y • **10**Blk

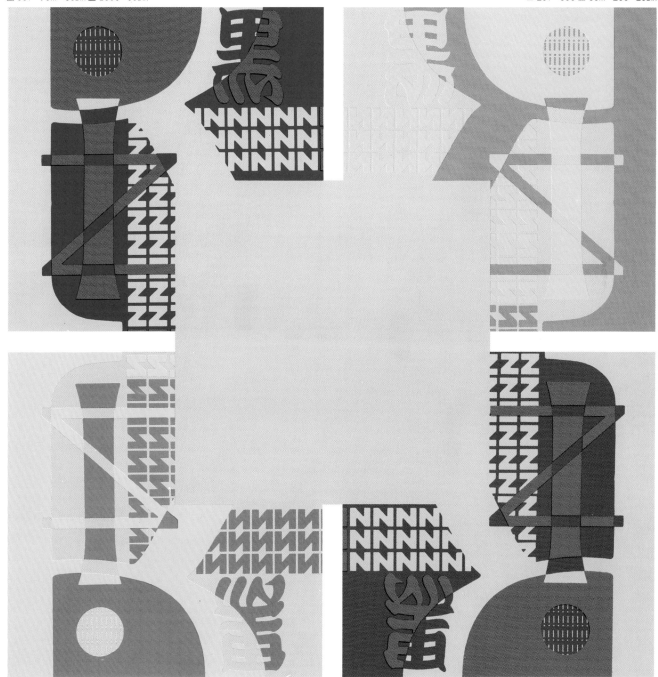

20Y · 40Blk

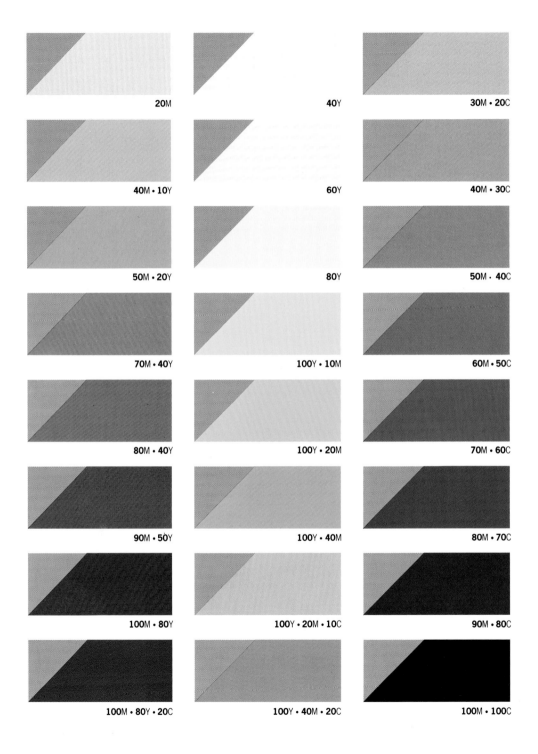

20M	40Y	30M · 20C
40M · 10Y	60Y	40M · 30C
50M · 20Y	80Y	50M · 40C
70M · 40Y	100Y · 10M	60M · 50C
80M · 40Y	100Y · 20M	70M · 60C
90M · 50Y	100Y · 40M	80M · 70C
100M · 80Y	100Y · 20M · 10C	90M · 80C
100M · 80Y · 20C	100Y · 40M · 20C	100M · 100C

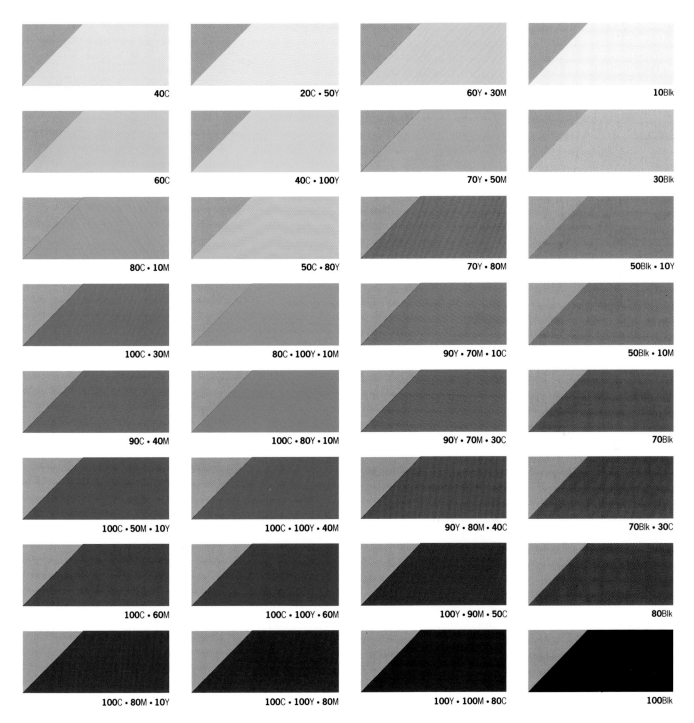

40C	20C • 50Y	60Y • 30M	10Blk
60C	40C • 100Y	70Y • 50M	30Blk
80C • 10M	50C • 80Y	70Y • 80M	50Blk • 10Y
100C • 30M	80C • 100Y • 10M	90Y • 70M • 10C	50Blk • 10M
90C • 40M	100C • 80Y • 10M	90Y • 70M • 30C	70Blk
100C • 50M • 10Y	100C • 100Y • 40M	90Y • 80M • 40C	70Blk • 30C
100C • 60M	100C • 100Y • 60M	100Y • 90M • 50C	80Blk
100C • 80M • 10Y	100C • 100Y • 80M	100Y • 100M • 80C	100Blk

20Y · 40Blk

NOTE: For technical information see page 6

100

90

Ossidet sterio binignuis
tultia, dolorat isogult it
gignuntisin stinuand. Flourida
prat gereafiunt quaecumque
trutent artsquati, quiateire
lurorist de corspore orum
semi uitantque tueri; sol etiam
caecat contra osidetsal utiquite

80

100Blk H/T · H/T's: **20**Y · **40**Blk 100Blk H/T · H/T's:**10**Y · **20**Blk

70

Ossidet sterio binignuis
tultia, dolorat isogult it
gignuntisin stinuand. Flourida
prat gereafiunt quaecumque
trutent artsquati, quiateire
lurorist de corspore orum
semi uitantque tueri; sol etiam
caecat contra osidetsal utiquite

60

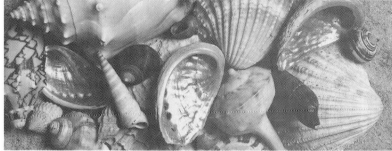

50Blk H/T · H/T's: **20**Y · **40**Blk 50Blk H/T · H/T's: **10**Y · **20**Blk

50

Ossidet sterio binignuis
tultia, dolorat isogult it
gignuntisin stinuand. Flourida
prat gereafiunt quaecumque
trutent artsquati, quiateire
lurorist de corspore orum
semi uitantque tueri; sol etiam
caecat contra osidetsal utiquite

40

30

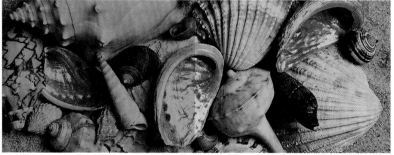

100Blk H/T · F/T's: **20**Y · **40**Blk 100Blk H/T · F/T's: **10**Y · **20**Blk

20

Ossidet sterio binignuis
tultia, dolorat isogult it
gignuntisin stinuand. Flourida
prat gereafiunt quaecumque
trutent artsquati, quiateire
lurorist de corspore orum
semi uitantque tueri; sol etiam
caecat contra osidetsal utiquite

10

0

H/T's: **20**Y · **40**Blk H/T's:**10**Y · **20**Blk

30Y · 50Blk

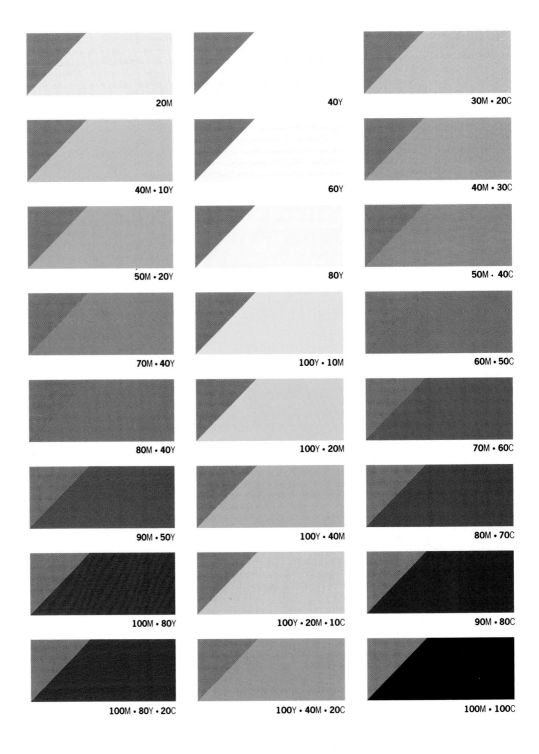

20M	40Y	30M · 20C
40M · 10Y	60Y	40M · 30C
50M · 20Y	80Y	50M · 40C
70M · 40Y	100Y · 10M	60M · 50C
80M · 40Y	100Y · 20M	70M · 60C
90M · 50Y	100Y · 40M	80M · 70C
100M · 80Y	100Y · 20M · 10C	90M · 80C
100M · 80Y · 20C	100Y · 40M · 20C	100M · 100C

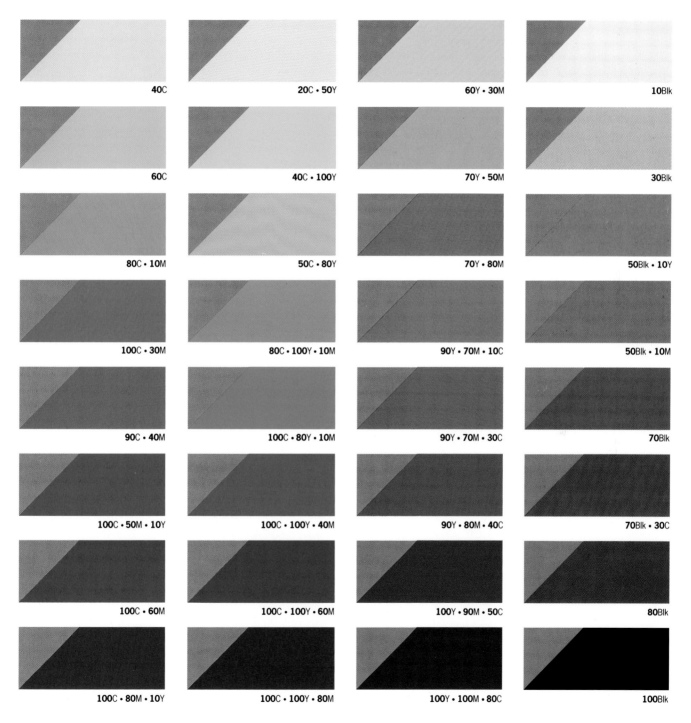

40C	20C • 50Y	60Y • 30M	10Blk
60C	40C • 100Y	70Y • 50M	30Blk
80C • 10M	50C • 80Y	70Y • 80M	50Blk • 10Y
100C • 30M	80C • 100Y • 10M	90Y • 70M • 10C	50Blk • 10M
90C • 40M	100C • 80Y • 10M	90Y • 70M • 30C	70Blk
100C • 50M • 10Y	100C • 100Y • 40M	90Y • 80M • 40C	70Blk • 30C
100C • 60M	100C • 100Y • 60M	100Y • 90M • 50C	80Blk
100C • 80M • 10Y	100C • 100Y • 80M	100Y • 100M • 80C	100Blk

30Y · 50Blk

NOTE: For technical information see page 6

100

90

80

Ossidet sterio binignuis tultia, dolorat isogult it gignuntisin stinuand. Flourida prat gereafiunt quaecumque **trutent artsquati, quiateire lurorist de corspore orum** semi uitantque tueri; sol etiam caecat contra osidetsal utiquite

100Blk H/T · H/T's: **30**Y · **50**Blk 100Blk H/T · H/T's: **15**Y · **25**Blk

70

60

Ossidet sterio binignuis tultia, dolorat isogult it gignuntisin stinuand. Flourida prat gereafiunt quaecumque trutent artsquati, quiateire lurorist de corspore orum semi uitantque tueri; sol etiam caecat contra osidetsal utiquite

50Blk H/T · H/T's: **30**Y · **50**Blk 50Blk H/T · H/T's: **15**Y · **25**Blk

50

40

30

Ossidet sterio binignuis tultia, dolorat isogult it gignuntisin stinuand. Flourida prat gereafiunt quaecumque **trutent artsquati, quiateire lurorist de corspore orum** semi uitantque tueri; sol etiam caecat contra osidetsal utiquite

100Blk H/T · F/T's: **30**Y · **50**Blk 100Blk H/T · F/T's: **15**Y · **25**Blk

20

10

0

Ossidet sterio binignuis tultia, dolorat isogult it gignuntisin stinuand. Flourida prat gereafiunt quaecumque **trutent artsquati, quiateire lurorist de corspore orum** semi uitantque tueri; sol etiam caecat contra osidetsal utiquite

H/T's: **30**Y · **50**Blk H/T's: **15**Y · **25**Blk

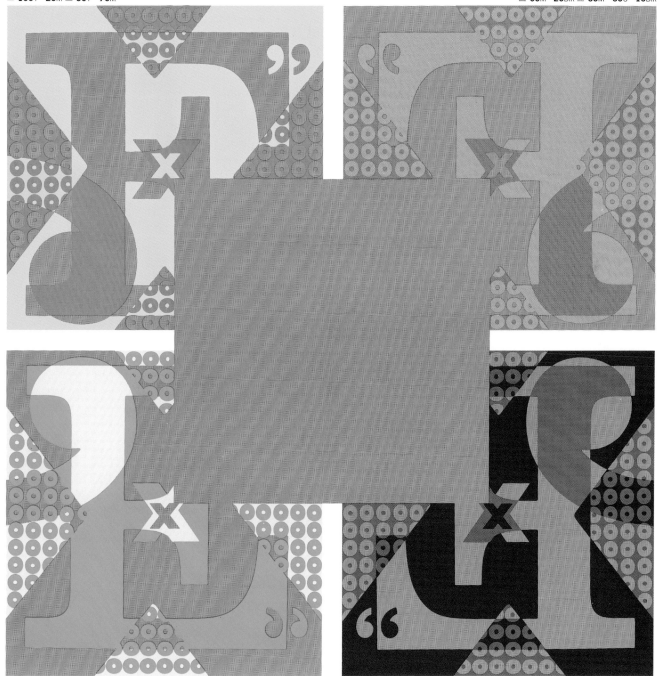

100Y • 20M ▦ 50Y • 70M

▦ 60M • 20Blk ▦ 30M • 30C • 10Blk

20Y • 10M ▦ 90Y • 70C

■ 100Y • 100M • 20C • 20Blk ▦ 50M • 50C • 50Blk

Natural grays represent ecology and conservation. Organic sulphur grays are the grays of the environment.

 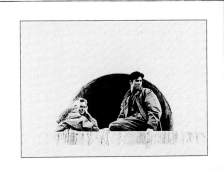

▶ One is beguiled into investigating these images by the contrast between the muted stone gray tinted photographs and their white background. The shapes within the photographs are given continuity by the stone tint. The result is a series of atmospheric fashion images.

3 weeks ago this was home to 4 species of parrot, 600 species of insect, a family of endangered monkeys and was helping to stop the climate changing in Manchester, Munich and Milan.

◀ A color palette consisting of gray-green, apricot yellow, and lilac interacts harmoniously to convey totally different images while retaining a sense of continuity through color. The dominant gray-green is picked up in the outlined title heading, in the central image, and, in the solid form of the graphics.

▲ A three-dimensional effect is clearly and brilliantly created by using sulphur gray for both the projected text and the photographic image. To literally underline the message behind this poster, three contrasting shades of blue – turquoise, ultramarine, and Baltic – are used for the background graphics and type.

july

~1 ~2 3 4 5 6 7 ~8 ~9 10 11 12 13 14 ~15 ~16 17 18 19 20 21

~22 ~23 24 25 26 27 28 ~29 ~30 31

◄ Although black is the predominant color for both graphics and type, it is soft khaki that plays the starring role. This gentle shade is used to link the harsh type to the graphics, while acting both as highlight and background to the illustration. A period feeling is evoked by the harmonious combination of pastel shades of khaki and rose against black and red.

◄ Ecology and conservation are the central themes of this image. The natural harmony between organic finishes is exemplified by the khaki of the textured and imprinted cardboard packaging, the undyed, rough fabric and the natural finish of the pencil. In each case, the company logo is sensitively matched with the materials, whether in black or as an imprint.

▲ Stone grey is used here to represent its name. Stone-tinted, delicate graphics float against pastel pink tinted images on a white background. Using a soft medium gray for the classic upper-case type adds a contemporary touch to the mellow tones of the central image.

81

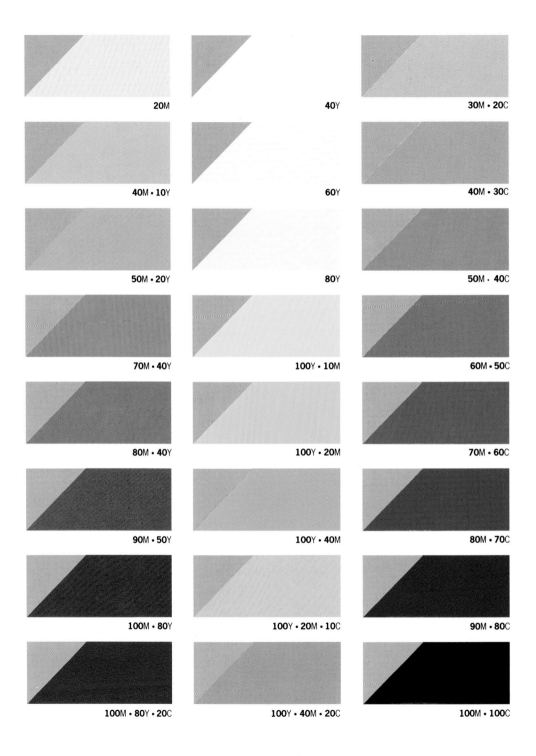

20M

40Y

30M·20C

40M·10Y

60Y

40M·30C

50M·20Y

80Y

50M·40C

70M·40Y

100Y·10M

60M·50C

80M·40Y

100Y·20M

70M·60C

90M·50Y

100Y·40M

80M·70C

100M·80Y

100Y·20M·10C

90M·80C

100M·80Y·20C

100Y·40M·20C

100M·100C

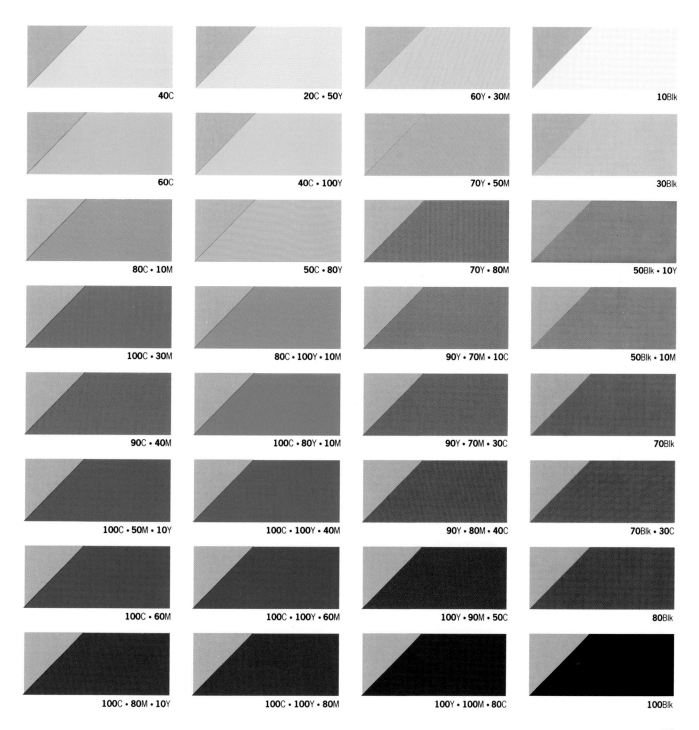

40C

20C • 50Y

60Y • 30M

10Blk

60C

40C • 100Y

70Y • 50M

30Blk

80C • 10M

50C • 80Y

70Y • 80M

50Blk • 10Y

100C • 30M

80C • 100Y • 10M

90Y • 70M • 10C

50Blk • 10M

90C • 40M

100C • 80Y • 10M

90Y • 70M • 30C

70Blk

100C • 50M • 10Y

100C • 100Y • 40M

90Y • 80M • 40C

70Blk • 30C

100C • 60M

100C • 100Y • 60M

100Y • 90M • 50C

80Blk

100C • 80M • 10Y

100C • 100Y • 80M

100Y • 100M • 80C

100Blk

10Y · 40Blk

NOTE: For technical information see page 6

100 —
90 —
80 —
70 —
60 —
50 —
40 —
30 —
20 —
10 —
0 —

Ossidet sterio binignuis
tultia, dolorat isogult it
gignuntisin stinuand. Flourida
prat gereafiunt quaecumque
trutent artsquati, quiateire
lurorist de corspore orum
semi uitantque tueri; sol etiam
caecat contra osidetsal utiquite

Ossidet sterio binignuis
tultia, dolorat isogult it
gignuntisin stinuand. Flourida
prat gereafiunt quaecumque
trutent artsquati, quiateire
lurorist de corspore orum
semi uitantque tueri; sol etiam
caecat contra osidetsal utiquite

Ossidet sterio binignuis
tultia, dolorat isogult it
gignuntisin stinuand. Flourida
prat gereafiunt quaecumque
trutent artsquati, quiateire
lurorist de corspore orum
semi uitantque tueri; sol etiam
caecat contra osidetsal utiquite

Ossidet sterio binignuis
tultia, dolorat isogult it
gignuntisin stinuand. Flourida
prat gereafiunt quaecumque
trutent artsquati, quiateire
lurorist de corspore orum
semi uitantque tueri; sol etiam
caecat contra osidetsal utiquite

100Blk H/T • H/T's: 10Y • 40Blk 100Blk H/T • H/T's: 5Y • 20Blk

50Blk H/T • H/T's: 10Y • 40Blk 50Blk H/T • H/T's: 5Y • 20Blk

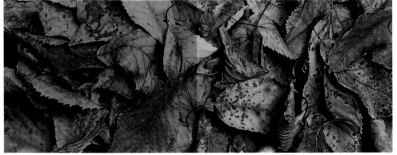

100Blk H/T • F/T's: 10Y • 40Blk 100Blk H/T • F/T's: 5Y • 20Blk

H/T's: 10Y • 40Blk H/T's: 5Y • 20Blk

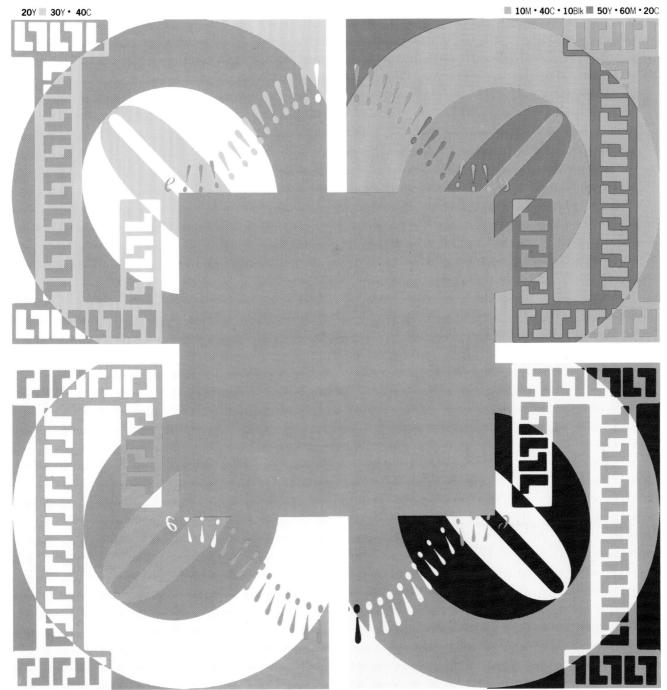

20Y ■ 30Y • 40C

■ 10M • 40C • 10Blk ■ 50Y • 60M • 20C

30Y ■ 40M • 10C • 10Blk

■ 40Y • 90M • 30C • 40Blk ■ 10M

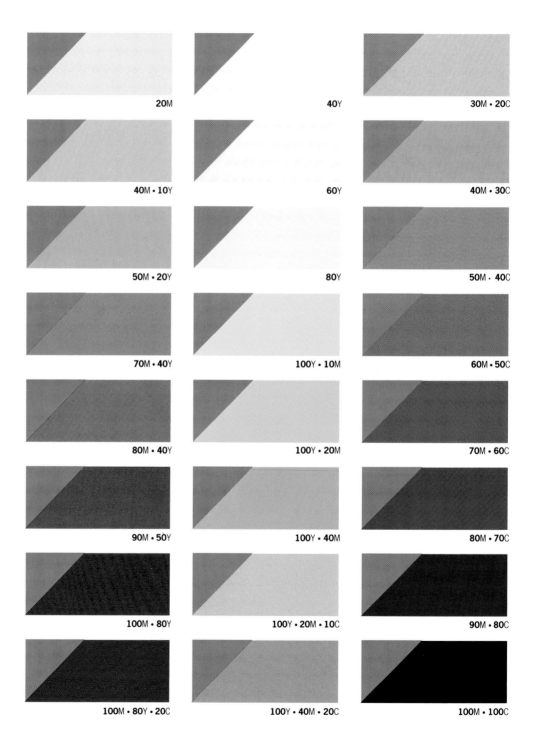

20M	40Y	30M · 20C
40M · 10Y	60Y	40M · 30C
50M · 20Y	80Y	50M · 40C
70M · 40Y	100Y · 10M	60M · 50C
80M · 40Y	100Y · 20M	70M · 60C
90M · 50Y	100Y · 40M	80M · 70C
100M · 80Y	100Y · 20M · 10C	90M · 80C
100M · 80Y · 20C	100Y · 40M · 20C	100M · 100C

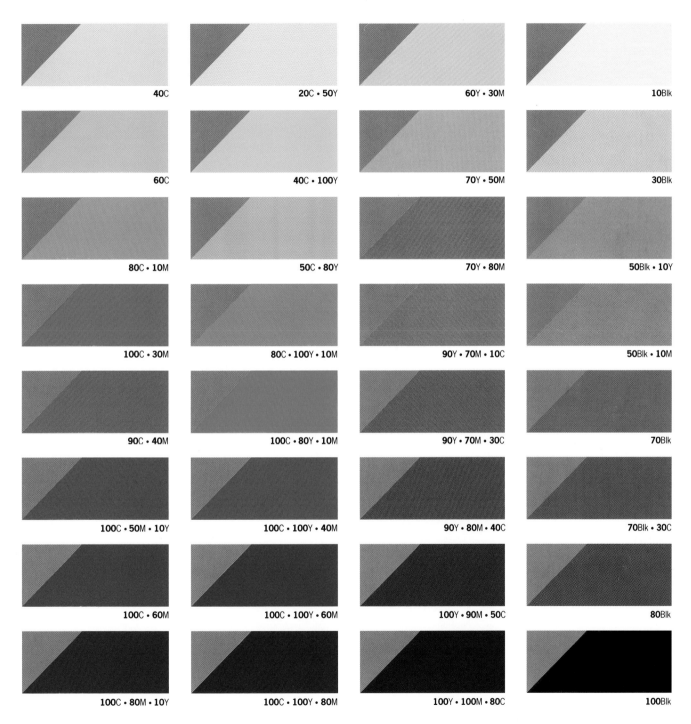

40C	20C • 50Y	60Y • 30M	10Blk
60C	40C • 100Y	70Y • 50M	30Blk
80C • 10M	50C • 80Y	70Y • 80M	50Blk • 10Y
100C • 30M	80C • 100Y • 10M	90Y • 70M • 10C	50Blk • 10M
90C • 40M	100C • 80Y • 10M	90Y • 70M • 30C	70Blk
100C • 50M • 10Y	100C • 100Y • 40M	90Y • 80M • 40C	70Blk • 30C
100C • 60M	100C • 100Y • 60M	100Y • 90M • 50C	80Blk
100C • 80M • 10Y	100C • 100Y • 80M	100Y • 100M • 80C	100Blk

10Y **· 60**Blk

NOTE: For technical information see page 6

Ossidet sterio binignuis tultia, dolorat isogult it gignuntisin stinuand. Flourida prat gereafiunt quaecumque **trutent artsquati, quiateire lurorist de corspore orum** semi uitantque tueri; sol etiam caecat contra osidetsal utiquite

Ossidet sterio binignuis tultia, dolorat isogult it gignuntisin stinuand. Flourida prat gereafiunt quaecumque **trutent artsquati, quiateire lurorist de corspore orum** semi uitantque tueri; sol etiam caecat contra osidetsal utiquite

Ossidet sterio binignuis tultia, dolorat isogult it gignuntisin stinuand. Flourida prat gereafiunt quaecumque **trutent artsquati, quiateire lurorist de corspore orum** semi uitantque tueri; sol etiam caecat contra osidetsal utiquite

Ossidet sterio binignuis tultia, dolorat isogult it gignuntisin stinuand. Flourida prat gereafiunt quaecumque **trutent artsquati, quiateire lurorist de corspore orum** semi uitantque tueri; sol etiam caecat contra osidetsal utiquite

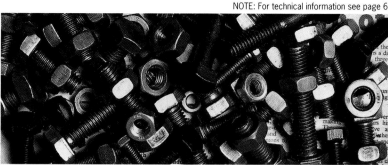

100Blk H/T • H/T's: **10**Y • **60**Blk **100**Blk H/T • H/T's: **5**Y • **30**Blk

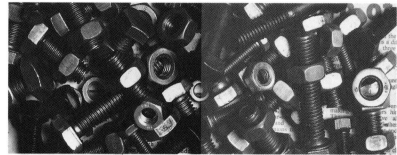

50Blk H/T • H/T's: **10**Y • **60**Blk **50**Blk H/T • H/T's: **5**Y • **30**Blk

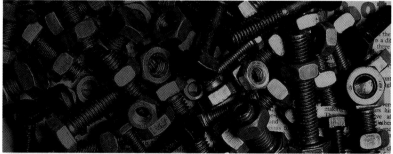

100Blk H/T • F/T's: **10**Y • **60**Blk **100**Blk H/T • F/T's: **5**Y • **30**Blk

H/T's: **10**Y • **60**Blk H/T's: **5**Y • **30**Blk

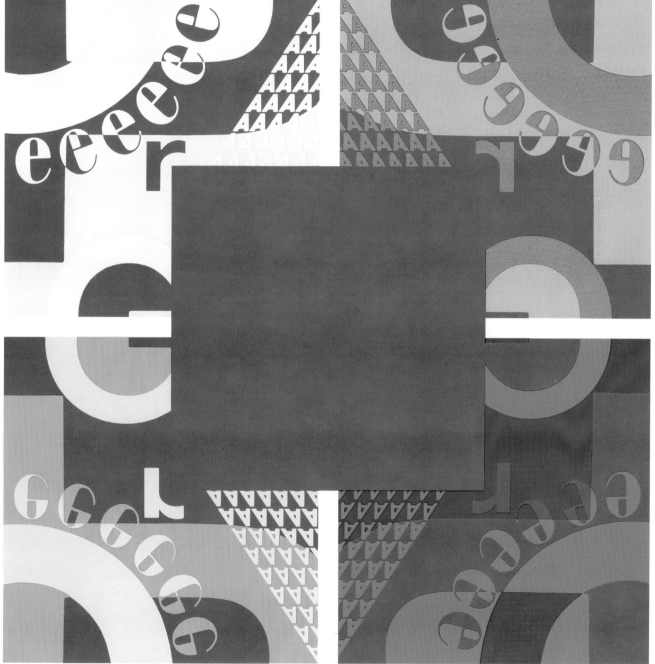

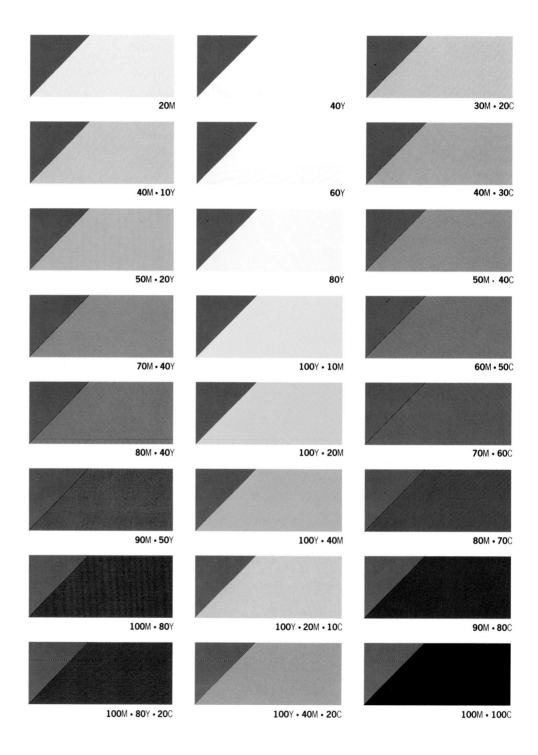

20M

40Y

30M · 20C

40M · 10Y

60Y

40M · 30C

50M · 20Y

80Y

50M · 40C

70M · 40Y

100Y · 10M

60M · 50C

80M · 40Y

100Y · 20M

70M · 60C

90M · 50Y

100Y · 40M

80M · 70C

100M · 80Y

100Y · 20M · 10C

90M · 80C

100M · 80Y · 20C

100Y · 40M · 20C

100M · 100C

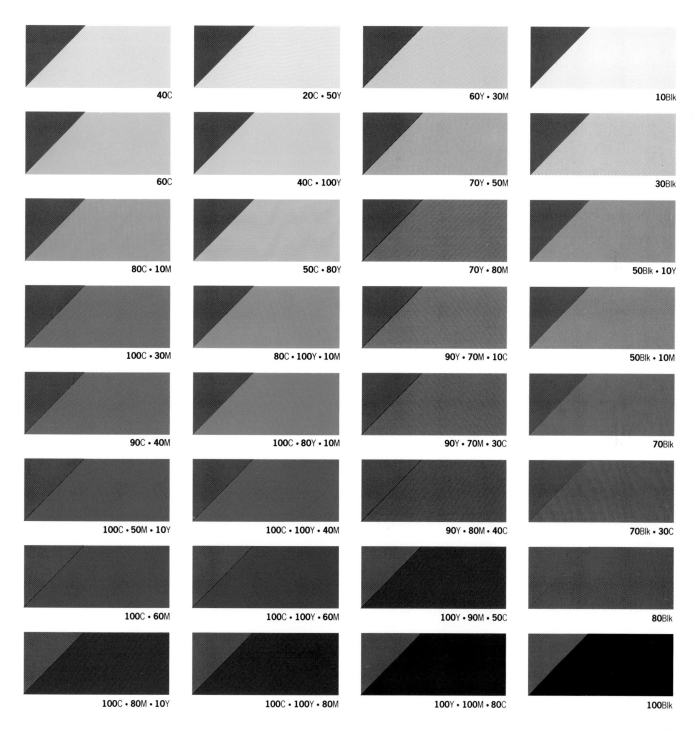

40C	20C • 50Y	60Y • 30M	10Blk
60C	40C • 100Y	70Y • 50M	30Blk
80C • 10M	50C • 80Y	70Y • 80M	50Blk • 10Y
100C • 30M	80C • 100Y • 10M	90Y • 70M • 10C	50Blk • 10M
90C • 40M	100C • 80Y • 10M	90Y • 70M • 30C	70Blk
100C • 50M • 10Y	100C • 100Y • 40M	90Y • 80M • 40C	70Blk • 30C
100C • 60M	100C • 100Y • 60M	100Y • 90M • 50C	80Blk
100C • 80M • 10Y	100C • 100Y • 80M	100Y • 100M • 80C	100Blk

10Y · 80Blk

NOTE: For technical information see page 6

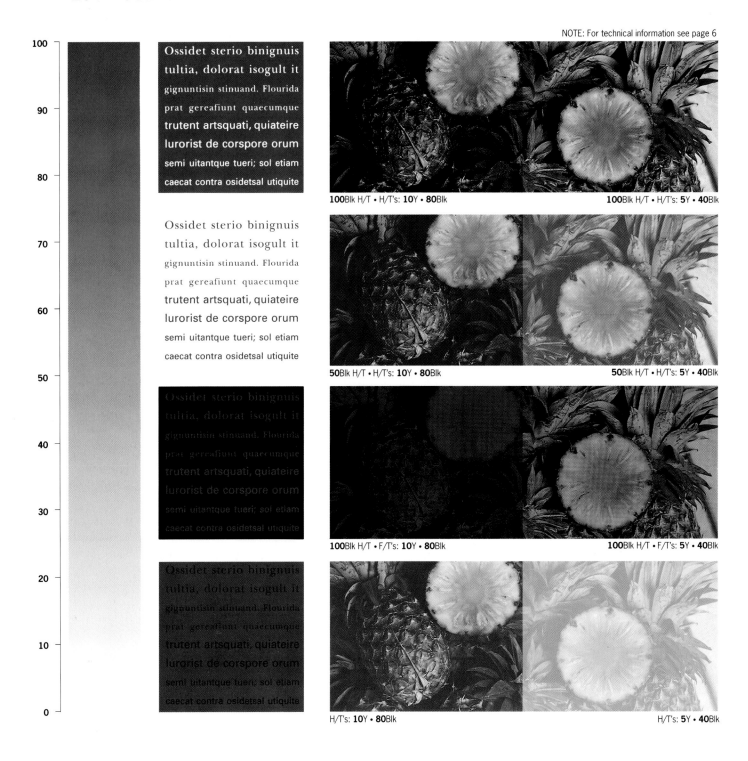

Ossidet sterio binignuis tultia, dolorat isogult it gignuntisin stinuand. Flourida prat gereafiunt quaecumque trutent artsquati, quiateire lurorist de corspore orum semi uitantque tueri; sol etiam caecat contra osidetsal utiquite

100Blk H/T · H/T's: **10**Y · **80**Blk 100Blk H/T · H/T's: **5**Y · **40**Blk

Ossidet sterio binignuis tultia, dolorat isogult it gignuntisin stinuand. Flourida prat gereafiunt quaecumque trutent artsquati, quiateire lurorist de corspore orum semi uitantque tueri; sol etiam caecat contra osidetsal utiquite

50Blk H/T · H/T's: **10**Y · **80**Blk 50Blk H/T · H/T's: **5**Y · **40**Blk

Ossidet sterio binignuis tultia, dolorat isogult it gignuntisin stinuand. Flourida prat gereafiunt quaecumque trutent artsquati, quiateire lurorist de corspore orum semi uitantque tueri; sol etiam caecat contra osidetsal utiquite

100Blk H/T · F/T's: **10**Y · **80**Blk 100Blk H/T · F/T's: **5**Y · **40**Blk

Ossidet sterio binignuis tultia, dolorat isogult it gignuntisin stinuand. Flourida prat gereafiunt quaecumque trutent artsquati, quiateire lurorist de corspore orum semi uitantque tueri; sol etiam caecat contra osidetsal utiquite

H/T's: **10**Y · **80**Blk H/T's: **5**Y · **40**Blk

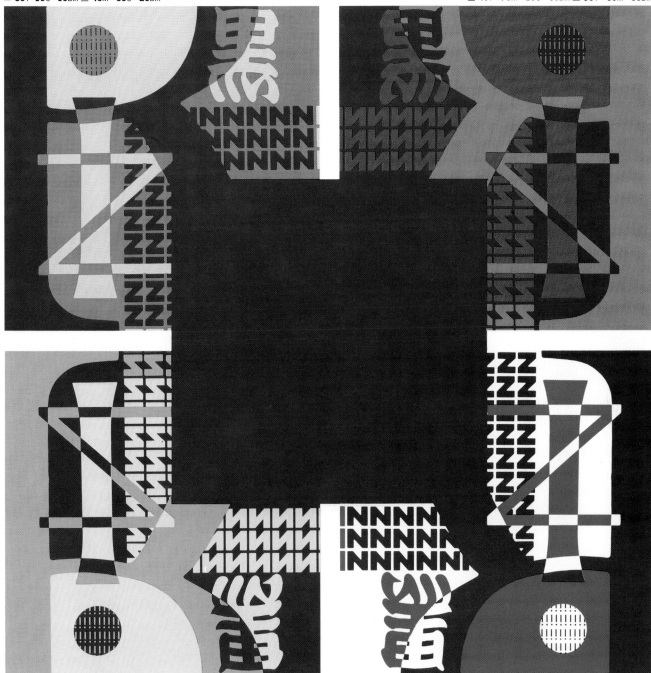

Yellowed grays are subdued and warm. Harmonious to greens and blues, they are sensitive to mood, yet utilitarian when the occasion demands.

▶ The addition of a yellow tint to the gentle gray background makes it receptive to the green of the graphics and typography. The gray mimics the color of a rabbit while creating a perfect background for the hand-drawn illustration and lettering. The image as a whole is contemporary and original in both color and design.

▲ A coal black background floats a humorous face formed by a collage of harmonious middle tone shades. The conventional tones make the face instantly recognizable, yet the dove gray eyebrows seem slightly incongruous. The gray performs two functions: it gives the face character and humor while linking the graphics to the minimalist typography.

◀ Three shades of gray assume the role of the sky in appropriate moods for each of three cameos representing the sun, the moon, and Saturn. The sun shines from the pale gray sky of daylight, red Saturn is enveloped in a gray aura of middle-tone light, while the blue moon glows from the depths of the dark gray midnight sky.

"Art must take reality by surprise"
Françoise Sagan

◀ Pastel gray forms a warm background harmonizing with the grayed tones of the pastel lettering. The contrast provided by white enhances the impact of the "fallen" lupin blue letter. The muted tones of these discreet pastels against a contrasting white base create an optical illusion in response to the handwritten statement below.

▲ A warm medium gray makes a sympathetic background for the simplest of graphic shapes. The contrast between the cut-out images and the soft gray brings clarity without harsh contrast. The utilitarian shades complement the basic structure of the page as a whole.

10M · 30Blk

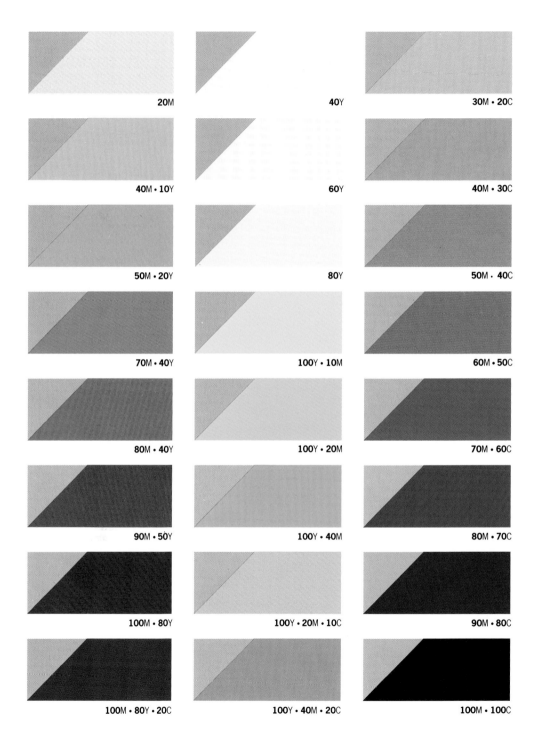

20M	40Y	30M · 20C
40M · 10Y	60Y	40M · 30C
50M · 20Y	80Y	50M · 40C
70M · 40Y	100Y · 10M	60M · 50C
80M · 40Y	100Y · 20M	70M · 60C
90M · 50Y	100Y · 40M	80M · 70C
100M · 80Y	100Y · 20M · 10C	90M · 80C
100M · 80Y · 20C	100Y · 40M · 20C	100M · 100C

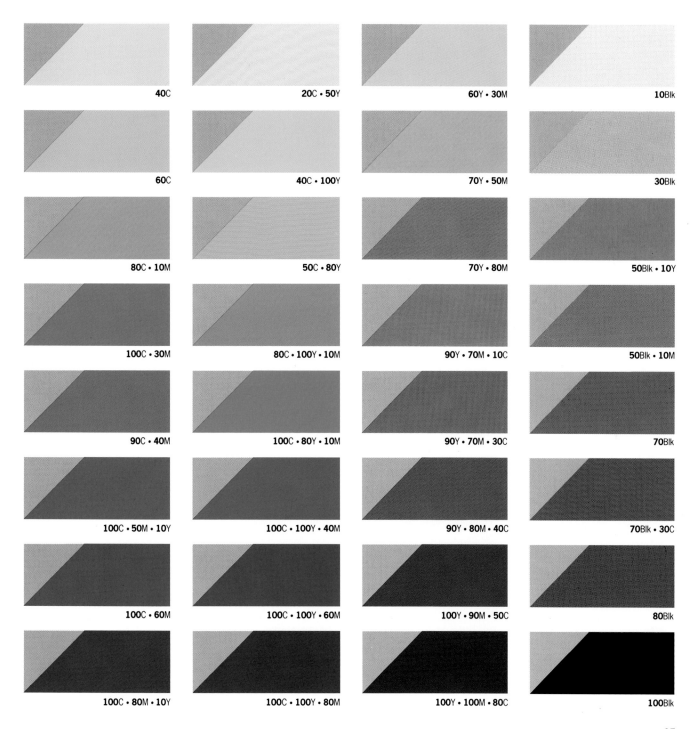

40C

20C · 50Y

60Y · 30M

10Blk

60C

40C · 100Y

70Y · 50M

30Blk

80C · 10M

50C · 80Y

70Y · 80M

50Blk · 10Y

100C · 30M

80C · 100Y · 10M

90Y · 70M · 10C

50Blk · 10M

90C · 40M

100C · 80Y · 10M

90Y · 70M · 30C

70Blk

100C · 50M · 10Y

100C · 100Y · 40M

90Y · 80M · 40C

70Blk · 30C

100C · 60M

100C · 100Y · 60M

100Y · 90M · 50C

80Blk

100C · 80M · 10Y

100C · 100Y · 80M

100Y · 100M · 80C

100Blk

10M · 30Blk

NOTE: For technical information see page 6

100

Ossidet sterio binignuis
tultia, dolorat isogult it
gignuntisin stinuand. Flourida
prat gereafiunt quaecumque
trutent artsquati, quiateire
lurorist de corspore orum
semi uitantque tueri; sol etiam
caecat contra osidetsal utiquite

90

100Blk H/T • H/T's: **10M** • **30**Blk 100Blk H/T • H/T's: **5M** • **15**Blk

80

Ossidet sterio binignuis
tultia, dolorat isogult it
gignuntisin stinuand. Flourida
prat gereafiunt quaecumque
trutent artsquati, quiateire
lurorist de corspore orum
semi uitantque tueri; sol etiam
caecat contra osidetsal utiquite

70

60

50Blk H/T • H/T's: **10M** • **30**Blk 50Blk H/T • H/T's: **5M** • **15**Blk

50

Ossidet sterio binignuis
tultia, dolorat isogult it
gignuntisin stinuand. Flourida
prat gereafiunt quaecumque
trutent artsquati, quiateire
lurorist de corspore orum
semi uitantque tueri; sol etiam
caecat contra osidetsal utiquite

40

30

100Blk H/T • F/T's: **10M** • **30**Blk 100Blk H/T • F/T's: **5M** • **15**Blk

20

Ossidet sterio binignuis
tultia, dolorat isogult it
gignuntisin stinuand. Flourida
prat gereafiunt quaecumque
trutent artsquati, quiateire
lurorist de corspore orum
semi uitantque tueri; sol etiam
caecat contra osidetsal utiquite

10

H/T's: **10M** • **30**Blk H/T's: **5M** • **15**Blk

0

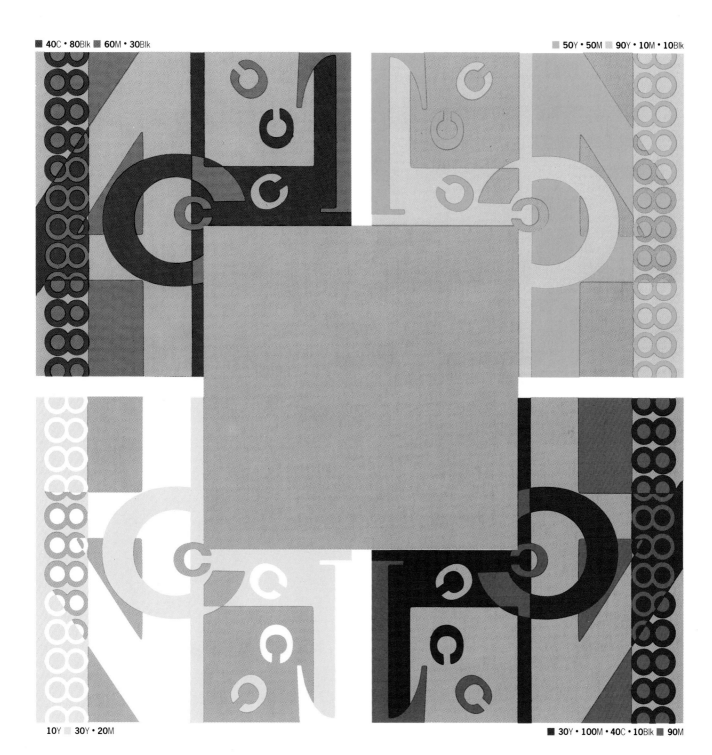

20Y · 30M · 20C · 10Blk

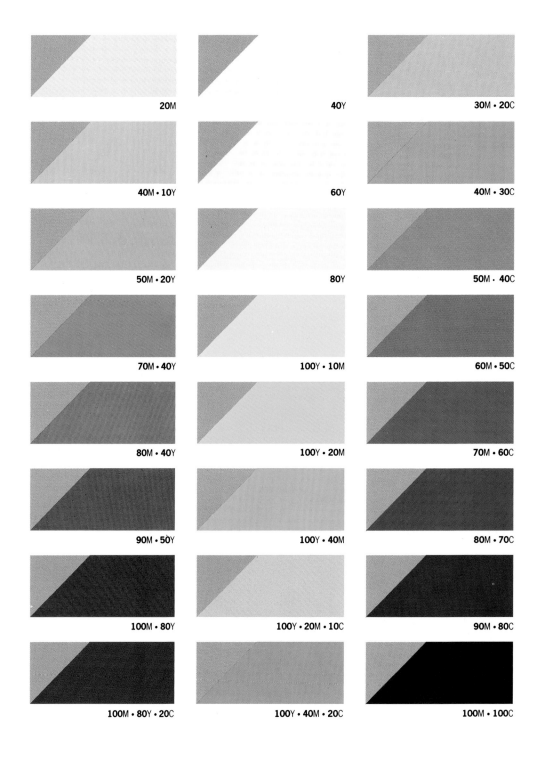

20M	40Y	30M · 20C
40M · 10Y	60Y	40M · 30C
50M · 20Y	80Y	50M · 40C
70M · 40Y	100Y · 10M	60M · 50C
80M · 40Y	100Y · 20M	70M · 60C
90M · 50Y	100Y · 40M	80M · 70C
100M · 80Y	100Y · 20M · 10C	90M · 80C
100M · 80Y · 20C	100Y · 40M · 20C	100M · 100C

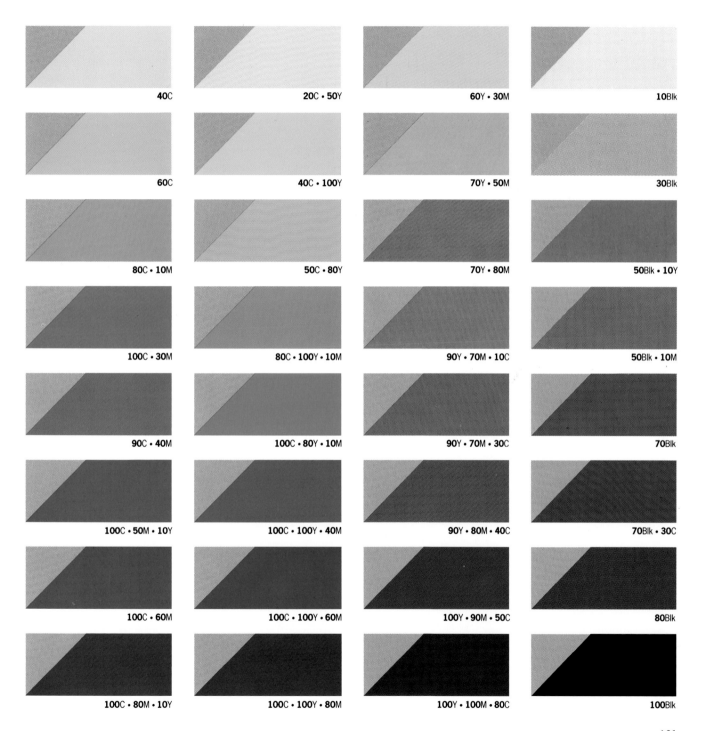

40C	20C • 50Y	60Y • 30M	10Blk
60C	40C • 100Y	70Y • 50M	30Blk
80C • 10M	50C • 80Y	70Y • 80M	50Blk • 10Y
100C • 30M	80C • 100Y • 10M	90Y • 70M • 10C	50Blk • 10M
90C • 40M	100C • 80Y • 10M	90Y • 70M • 30C	70Blk
100C • 50M • 10Y	100C • 100Y • 40M	90Y • 80M • 40C	70Blk • 30C
100C • 60M	100C • 100Y • 60M	100Y • 90M • 50C	80Blk
100C • 80M • 10Y	100C • 100Y • 80M	100Y • 100M • 80C	100Blk

20Y · 30M · 20C · 10Blk

NOTE: For technical information see page 6

Ossidet sterio binignuis tultia, dolorat isogult it gignuntisin stinuand. Flourida prat gereafiunt quaecumque **trutent artsquati, quiateire lurorist de corspore orum** semi uitantque tueri; sol etiam caecat contra osidetsal utiquite

Ossidet sterio binignuis tultia, dolorat isogult it gignuntisin stinuand. Flourida prat gereafiunt quaecumque trutent artsquati, quiateire lurorist de corspore orum semi uitantque tueri; sol etiam caecat contra osidetsal utiquite

Ossidet sterio binignuis tultia, dolorat isogult it gignuntisin stinuand. Flourida prat gereafiunt quaecumque **trutent artsquati, quiateire lurorist de corspore orum** semi uitantque tueri; sol etiam caecat contra osidetsal utiquite

Ossidet sterio binignuis tultia, dolorat isogult it gignuntisin stinuand. Flourida prat gereafiunt quaecumque **trutent artsquati, quiateire lurorist de corspore orum** semi uitantque tucri; sol etiam caecat contra osidetsal utiquite

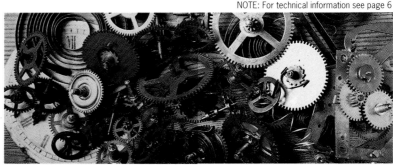

100Blk H/T • H/T's: **20Y • 30M • 20C • 10**Blk 100Blk H/T • H/T's: **10Y • 15M • 10C • 5**Blk

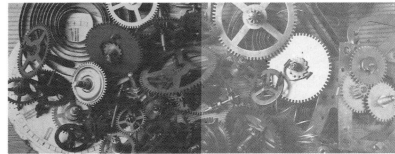

50Blk H/T • H/T's: **20Y • 30M • 20C • 10**Blk 50Blk H/T • H/T's: **10Y • 15M • 10C • 5**Blk

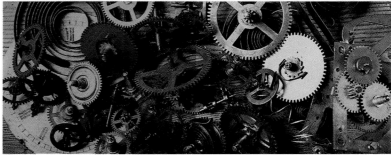

100Blk H/T • F/T's: **20Y • 30M • 20C • 10**Blk 100Blk H/T • F/T's: **10Y • 15M • 10C • 5**Blk

H/T's: **20Y • 30M • 20C • 10**Blk H/T's: **10Y • 15M • 10C • 5**Blk

20M · 50Blk

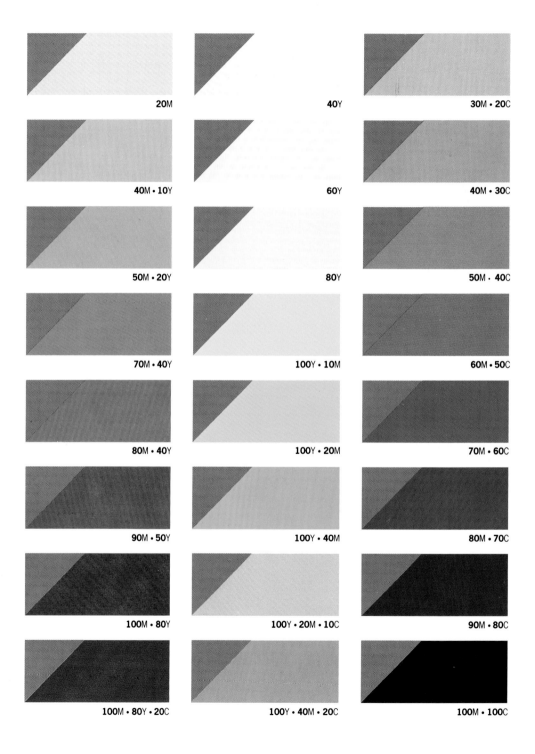

20M

40Y

30M · 20C

40M · 10Y

60Y

40M · 30C

50M · 20Y

80Y

50M · 40C

70M · 40Y

100Y · 10M

60M · 50C

80M · 40Y

100Y · 20M

70M · 60C

90M · 50Y

100Y · 40M

80M · 70C

100M · 80Y

100Y · 20M · 10C

90M · 80C

100M · 80Y · 20C

100Y · 40M · 20C

100M · 100C

104

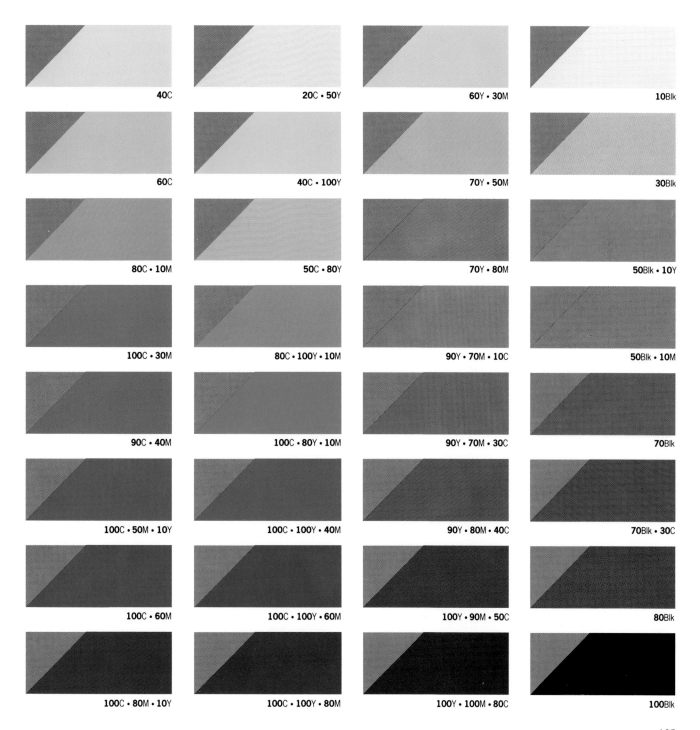

40C	20C • 50Y	60Y • 30M	10Blk
60C	40C • 100Y	70Y • 50M	30Blk
80C • 10M	50C • 80Y	70Y • 80M	50Blk • 10Y
100C • 30M	80C • 100Y • 10M	90Y • 70M • 10C	50Blk • 10M
90C • 40M	100C • 80Y • 10M	90Y • 70M • 30C	70Blk
100C • 50M • 10Y	100C • 100Y • 40M	90Y • 80M • 40C	70Blk • 30C
100C • 60M	100C • 100Y • 60M	100Y • 90M • 50C	80Blk
100C • 80M • 10Y	100C • 100Y • 80M	100Y • 100M • 80C	100Blk

20M · 50Blk

NOTE: For technical information see page 6

100

90

Ossidet sterio binignuis
tultia, dolorat isogult it
gignuntisin stinuand. Flourida
prat gereafiunt quaecumque
trutent artsquati, quiateire
lurorist de corspore orum
semi uitantque tueri; sol etiam
caecat contra osidetsal utiquite

80

100Blk H/T · H/T's: **20M · 50**Blk 100Blk H/T · H/T's: **10M · 25**Blk

70

Ossidet sterio binignuis
tultia, dolorat isogult it
gignuntisin stinuand. Flourida
prat gereafiunt quaecumque
trutent artsquati, quiateire
lurorist de corspore orum
semi uitantque tueri; sol etiam
caecat contra osidetsal utiquite

60

50

50Blk H/T · H/T's: **20M · 50**Blk 50Blk H/T · H/T's: **10M · 25**Blk

Ossidet sterio binignuis
tultia, dolorat isogult it
gignuntisin stinuand. Flourida
prat gereafiunt quaecumque
trutent artsquati, quiateire
lurorist de corspore orum
semi uitantque tueri; sol etiam
caecat contra osidetsal utiquite

40

30

100Blk H/T · F/T's: **20M · 50**Blk 100Blk H/T · F/T's: **10M · 25**Blk

20

Ossidet sterio binignuis
tultia, dolorat isogult it
gignuntisin stinuand. Flourida
prat gereafiunt quaecumque
trutent artsquati, quiateire
lurorist de corspore orum
semi uitantque tueri; sol etiam
caecat contra osidetsal utiquite

10

0

H/T's: **20M · 50**Blk H/T's: **10M · 25**Blk

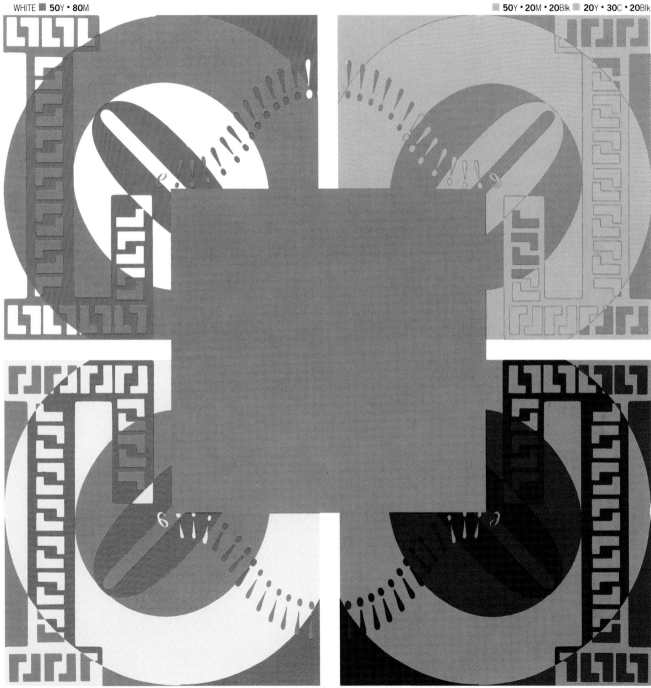

WHITE ■ 50Y • 80M

■ 50Y • 20M • 20Blk ■ 20Y • 30C • 20Blk

■ 20Y • 10M ■ 10Y • 60M • 20C • 20Blk

■ 90Y • 100M • 10C • 20Blk ■ 80Y • 100M • 50C • 40Blk

30M·10C·50Blk

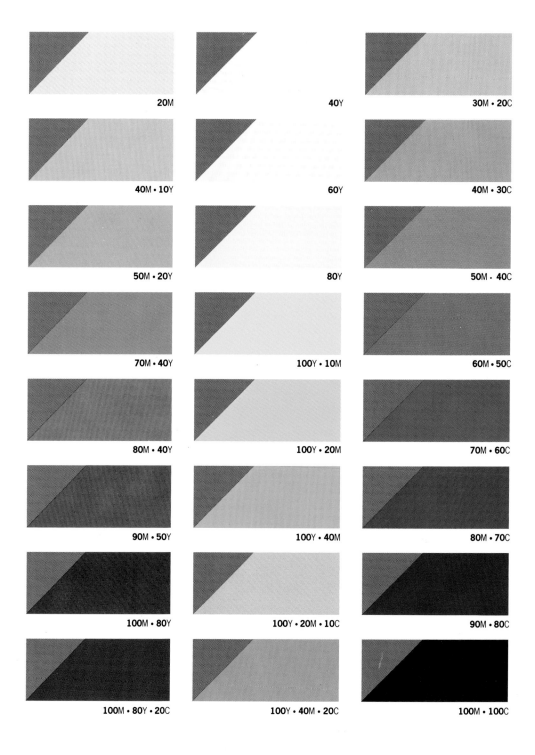

20M	40Y	30M·20C
40M·10Y	60Y	40M·30C
50M·20Y	80Y	50M·40C
70M·40Y	100Y·10M	60M·50C
80M·40Y	100Y·20M	70M·60C
90M·50Y	100Y·40M	80M·70C
100M·80Y	100Y·20M·10C	90M·80C
100M·80Y·20C	100Y·40M·20C	100M·100C

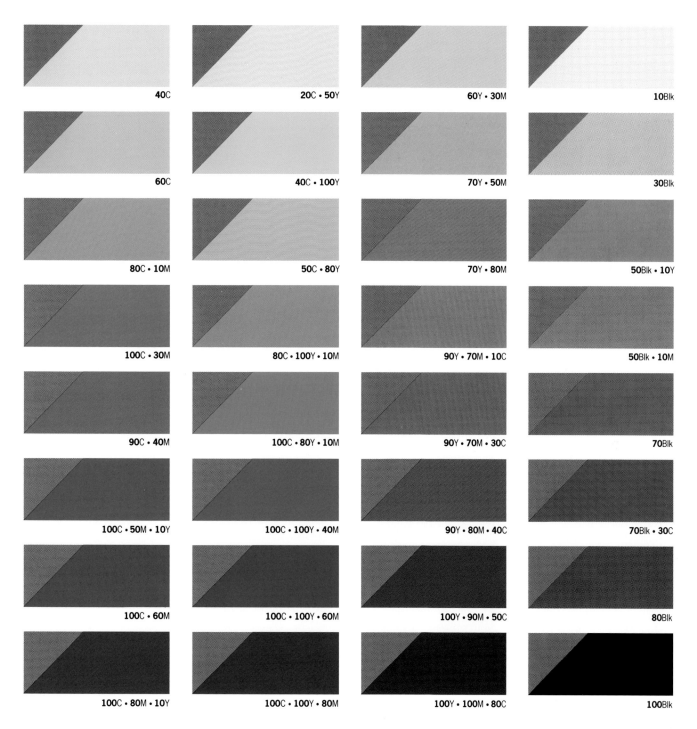

40C	20C • 50Y	60Y • 30M	10Blk
60C	40C • 100Y	70Y • 50M	30Blk
80C • 10M	50C • 80Y	70Y • 80M	50Blk • 10Y
100C • 30M	80C • 100Y • 10M	90Y • 70M • 10C	50Blk • 10M
90C • 40M	100C • 80Y • 10M	90Y • 70M • 30C	70Blk
100C • 50M • 10Y	100C • 100Y • 40M	90Y • 80M • 40C	70Blk • 30C
100C • 60M	100C • 100Y • 60M	100Y • 90M • 50C	80Blk
100C • 80M • 10Y	100C • 100Y • 80M	100Y • 100M • 80C	100Blk

30M · 10C · 50Blk

NOTE: For technical information see page 6

Ossidet sterio binignuis tultia, dolorat isogult it gignuntisin stinuand. Flourida prat gereafiunt quaecumque **trutent artsquati, quiateire lurorist de corspore orum** semi uitantque tueri; sol etiam caecat contra osidetsal utiquite

100Blk H/T · H/T's: **30M · 10C · 50**Blk 100Blk H/T · H/T's: **15M · 5C · 25**Blk

Ossidet sterio binignuis tultia, dolorat isogult it gignuntisin stinuand. Flourida prat gereafiunt quaecumque **trutent artsquati, quiateire lurorist de corspore orum** semi uitantque tueri; sol etiam caecat contra osidetsal utiquite

50Blk H/T · H/T's: **30M · 10C · 50**Blk 50Blk H/T · H/T's: **15M · 5C · 25**Blk

Ossidet sterio binignuis tultia, dolorat isogult it gignuntisin stinuand. Flourida prat gereafiunt quaecumque **trutent artsquati, quiateire lurorist de corspore orum** semi uitantque tueri; sol etiam caecat contra osidetsal utiquite

100Blk H/T · F/T's: **30M · 10C · 50**Blk 100Blk H/T · F/T's: **15M · 5C · 25**Blk

Ossidet sterio binignuis tultia, dolorat isogult it gignuntisin stinuand. Flourida prat gereafiunt quaecumque **trutent artsquati, quiateire lurorist de corspore orum** semi uitantque tueri; sol etiam caecat contra osidetsal utiquite

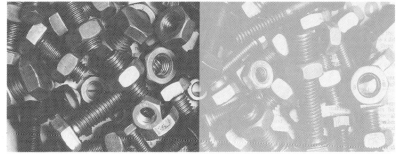

H/T's: **30M · 10C · 50**Blk H/T's: **15M · 5C · 25**Blk

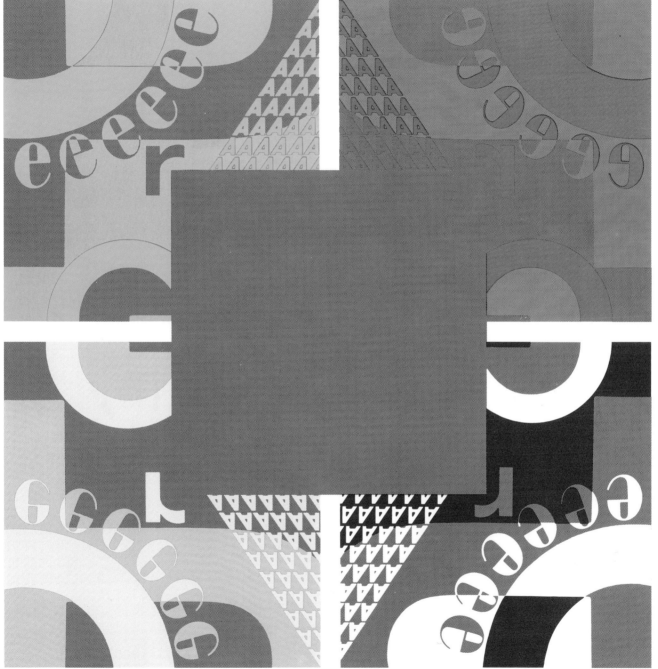

30Y · 60M · 40C · 50Blk

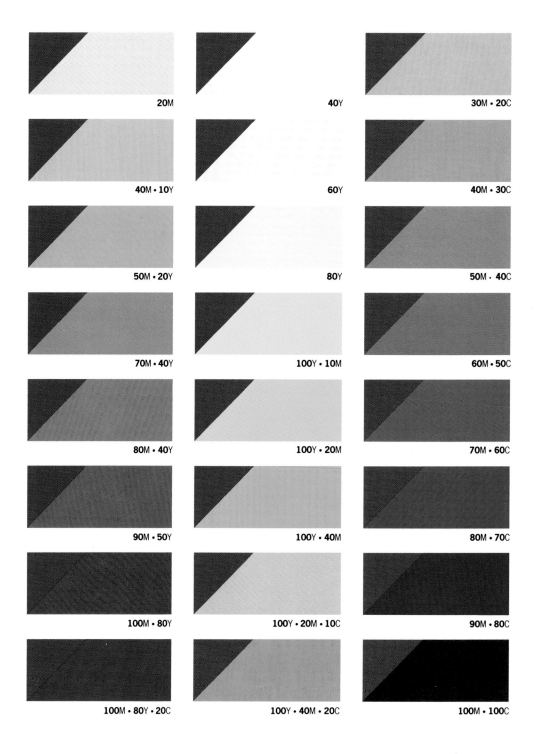

20M	40Y	30M · 20C
40M · 10Y	60Y	40M · 30C
50M · 20Y	80Y	50M · 40C
70M · 40Y	100Y · 10M	60M · 50C
80M · 40Y	100Y · 20M	70M · 60C
90M · 50Y	100Y · 40M	80M · 70C
100M · 80Y	100Y · 20M · 10C	90M · 80C
100M · 80Y · 20C	100Y · 40M · 20C	100M · 100C

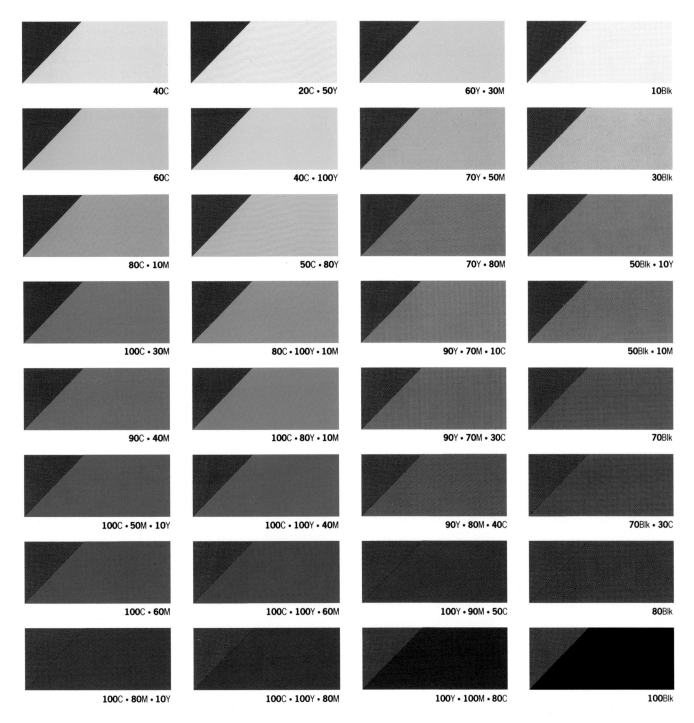

40C	20C • 50Y	60Y • 30M	10Blk
60C	40C • 100Y	70Y • 50M	30Blk
80C • 10M	50C • 80Y	70Y • 80M	50Blk • 10Y
100C • 30M	80C • 100Y • 10M	90Y • 70M • 10C	50Blk • 10M
90C • 40M	100C • 80Y • 10M	90Y • 70M • 30C	70Blk
100C • 50M • 10Y	100C • 100Y • 40M	90Y • 80M • 40C	70Blk • 30C
100C • 60M	100C • 100Y • 60M	100Y • 90M • 50C	80Blk
100C • 80M • 10Y	100C • 100Y • 80M	100Y • 100M • 80C	100Blk

113

30Y · 60M · 40C · 50Blk

NOTE: For technical information see page 6

Ossidet sterio binignuis
tultia, dolorat isogult it
gignuntisin stinuand. Flourida
prat gereafiunt quaecumque
trutent artsquati, quiateire
lurorist de corspore orum
semi uitantque tueri; sol etiam
caecat contra osidetsal utiquite

Ossidet sterio binignuis
tultia, dolorat isogult it
gignuntisin stinuand. Flourida
prat gereafiunt quaecumque
trutent artsquati, quiateire
lurorist de corspore orum
semi uitantque tueri; sol etiam
caecat contra osidetsal utiquite

Ossidet sterio binignuis
tultia, dolorat isogult it
gignuntisin stinuand. Flourida
prat gereafiunt quaecumque
trutent artsquati, quiateire
lurorist de corspore orum
semi uitantque tueri; sol etiam
caecat contra osidetsal utiquite

Ossidet sterio binignuis
tultia, dolorat isogult it
gignuntisin stinuand. Flourida
prat gereafiunt quaecumque
trutent artsquati, quiateire
lurorist de corspore orum
semi uitantque tueri; sol etiam
caecat contra osidetsal utiquite

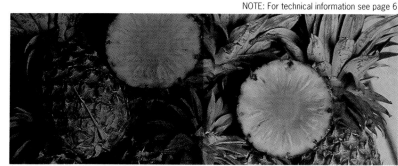

100Blk H/T • H/T's: **30**Y • **60**M • **40**C • **50**Blk 100Blk H/T • H/T's: **15**Y • **30**M • **20**C • **25**Blk

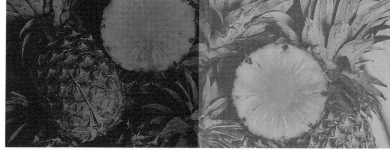

50Blk H/T • H/T's: **30**Y • **60**M • **40**C • **50**Blk 50Blk H/T • H/T's: **15**Y • **30**M • **20**C • **25**Blk

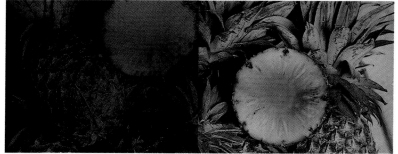

100Blk H/T • F/T's: **30**Y • **60**M • **40**C • **50**Blk 100Blk H/T • F/T's: **15**Y • **30**M • **20**C • **25**Blk

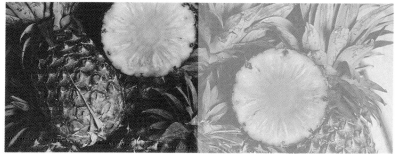

H/T's: **30**Y • **60**M • **40**C • **50**Blk H/T's: **15**Y • **30**M • **20**C • **25**Blk

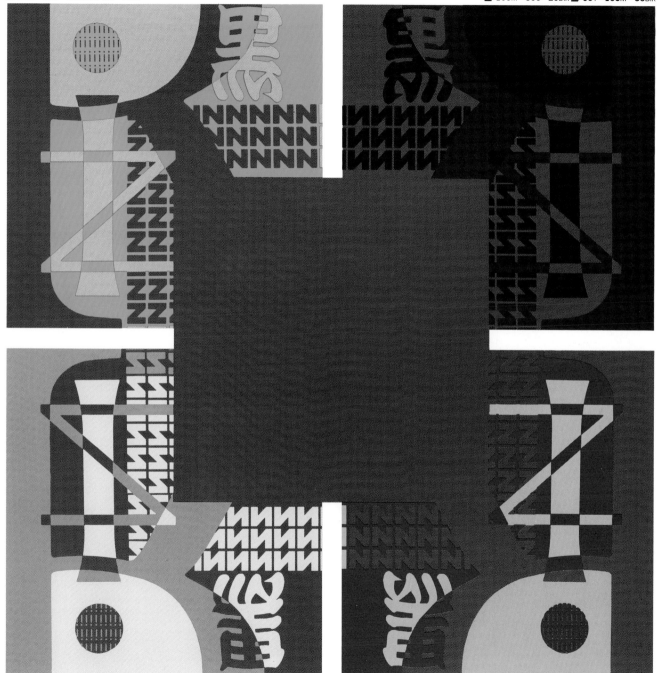

Magenta has entered gray followed by cyan. Sensual, harmonious and receptive hues, reminiscent of velvet. These soft, sooty shades complement magenta.

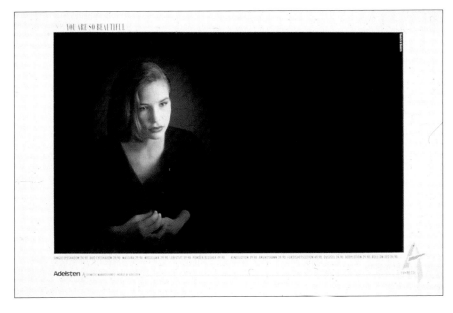

▲ Coal black evokes a soft, velvety atmosphere, while mole gray forms a spotlight behind the central image. The soft gray also provides a contrast with the highlighted skin tones of the face and neck, giving the impression of alabaster against black velvet.

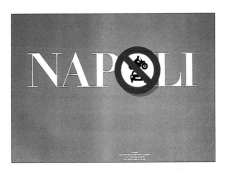

◀ Through their harmony of hues and intensities, tinted overlays create a contemporary graphic design. The subtlety of the monochrome shading of grays is in dramatic contrast to the strong black. The use of a soft apricot tint combined with carbon graphics creates a complementary image of a totally different character. Stone gray type provides continuity with the images while contrasting with the white background.

▲ A receptive warm gray with a tint of magenta provides a harmonious background, giving a three-dimensional appearance to the graphics. The softness of the mole gray enhances the impact of the crimson, white, and black of the road sign.

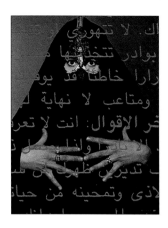

The monochrome photographic image of an Arab woman shrouded in black against a flat gray background is brought to life by the introduction of magenta-tinted dove gray calligraphy. The Arabic script forms a curtain of warm, sensuous color giving a third dimension to the design.

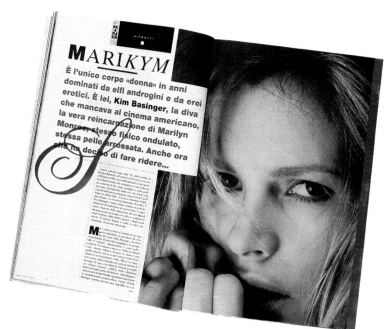

A warm, magenta-tinged gray tint overlay has been applied to the photograph, bringing depth and interest to the image while relating to the magenta of the typography. The coldness of the black type on white contrasts with the warmth of the calligraphic letter, while the tint of the photo tones with the magenta border.

Sooty gray typography softens the black page numbers. The pearl gray background has a tint of magenta, complementing the sophisticated gray type. The floating photographic images and the black digits form a vibrant contrast with the soft pearl gray, while the stronger gray links the two dimensions.

10C·40Blk

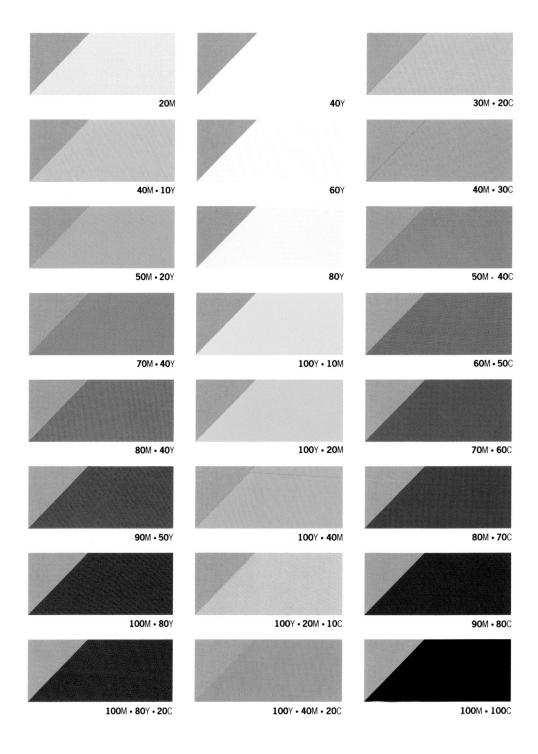

20M

40Y

30M·20C

40M·10Y

60Y

40M·30C

50M·20Y

80Y

50M·40C

70M·40Y

100Y·10M

60M·50C

80M·40Y

100Y·20M

70M·60C

90M·50Y

100Y·40M

80M·70C

100M·80Y

100Y·20M·10C

90M·80C

100M·80Y·20C

100Y·40M·20C

100M·100C

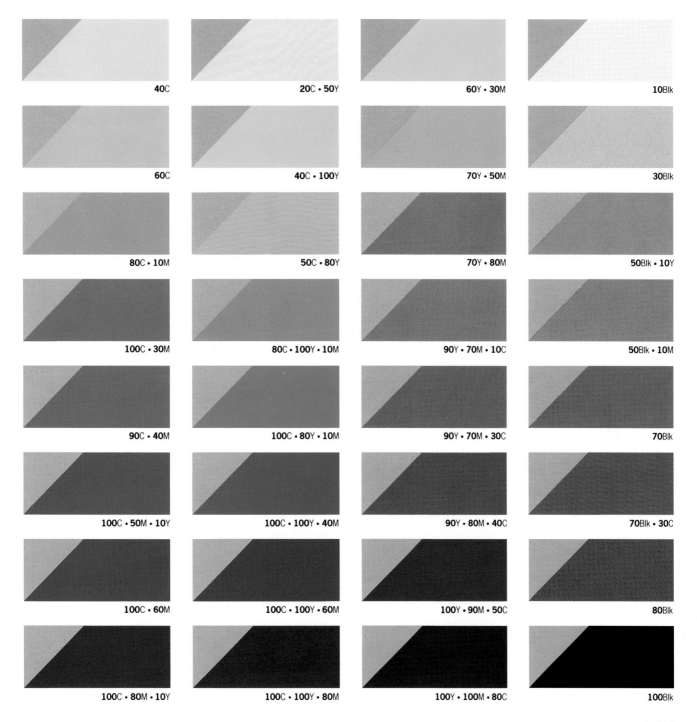

40C	20C • 50Y	60Y • 30M	10Blk
60C	40C • 100Y	70Y • 50M	30Blk
80C • 10M	50C • 80Y	70Y • 80M	50Blk • 10Y
100C • 30M	80C • 100Y • 10M	90Y • 70M • 10C	50Blk • 10M
90C • 40M	100C • 80Y • 10M	90Y • 70M • 30C	70Blk
100C • 50M • 10Y	100C • 100Y • 40M	90Y • 80M • 40C	70Blk • 30C
100C • 60M	100C • 100Y • 60M	100Y • 90M • 50C	80Blk
100C • 80M • 10Y	100C • 100Y • 80M	100Y • 100M • 80C	100Blk

NOTE: For technical information see page 6

100
90
80
70
60
50
40
30
20
10
0

Ossidet sterio binignuis
tultia, dolorat isogult it
gignuntisin stinuand. Flourida
prat gereafiunt quaecumque
trutent artsquati, quiateire
lurorist de corspore orum
semi uitantque tueri; sol etiam
caecat contra osidetsal utiquite

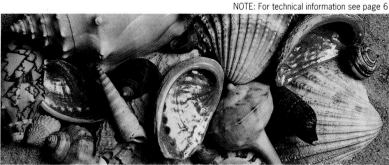

100Blk H/T • **H/T's: 10**C · **40**Blk 100Blk H/T • **H/T's: 5**C · **20**Blk

Ossidet sterio binignuis
tultia, dolorat isogult it
gignuntisin stinuand. Flourida
prat gereafiunt quaecumque
trutent artsquati, quiateire
lurorist de corspore orum
semi uitantque tueri; sol etiam
caecat contra osidetsal utiquite

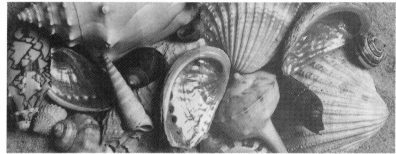

50Blk H/T • **H/T's: 10**C · **40**Blk 50Blk H/T • **H/T's: 5**C · **20**Blk

Ossidet sterio binignuis
tultia, dolorat isogult it
gignuntisin stinuand. Flourida
prat gereafiunt quaecumque
trutent artsquati, quiateire
lurorist de corspore orum
semi uitantque tueri; sol etiam
caecat contra osidetsal utiquite

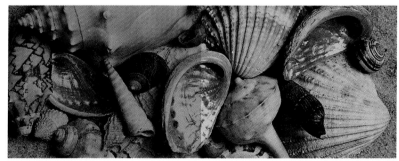

100Blk H/T • **F/T's: 10**C · **40**Blk 100Blk H/T • **F/T's: 5**C · **20**Blk

Ossidet sterio binignuis
tultia, dolorat isogult it
gignuntisin stinuand. Flourida
prat gereafiunt quaecumque
trutent artsquati, quiateire
lurorist de corspore orum
semi uitantque tueri; sol etiam
caecat contra osidetsal utiquite

H/T's: 10C · **40**Blk **H/T's: 5**C · **20**Blk

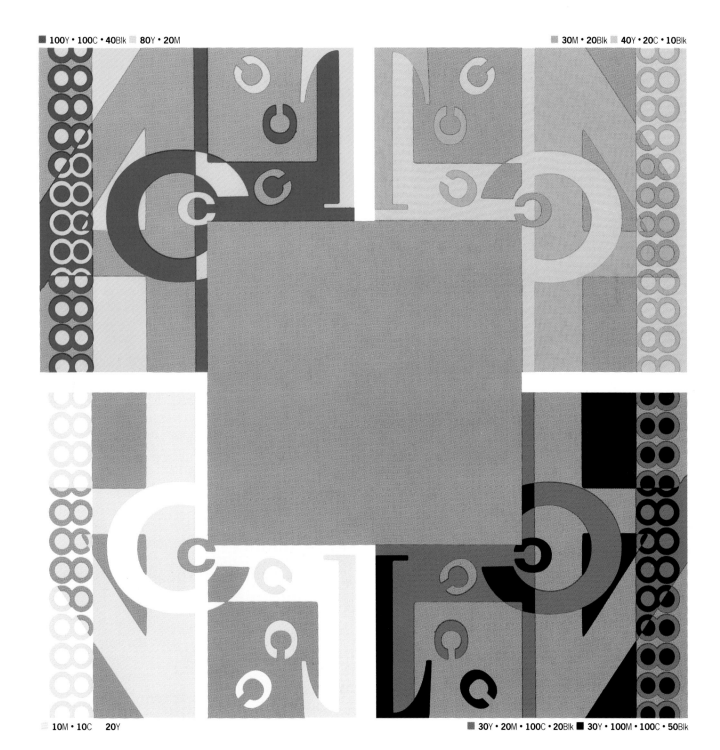

100Y • 100C • 40Blk 80Y • 20M

30M • 20Blk 40Y • 20C • 10Blk

10M • 10C 20Y

30Y • 20M • 100C • 20Blk 30Y • 100M • 100C • 50Blk

20Y・**30**M・**40**C・**20**Blk

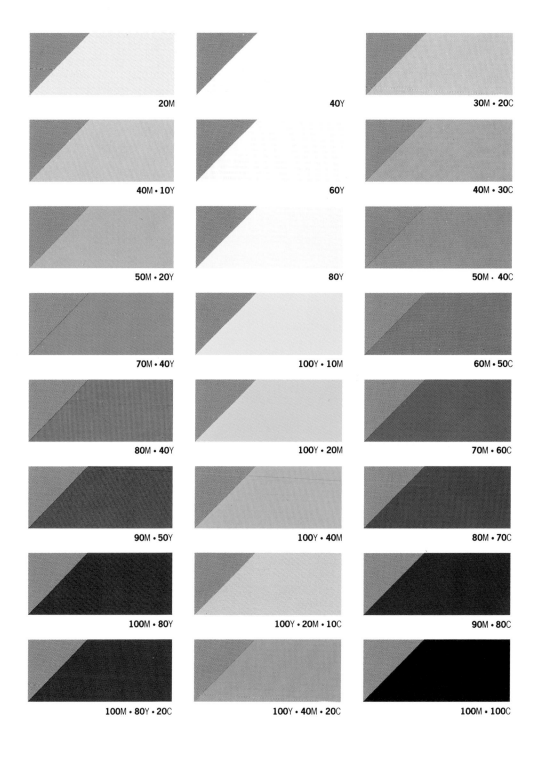

20M	40Y	30M・20C
40M・10Y	60Y	40M・30C
50M・20Y	80Y	50M・40C
70M・40Y	100Y・10M	60M・50C
80M・40Y	100Y・20M	70M・60C
90M・50Y	100Y・40M	80M・70C
100M・80Y	100Y・20M・10C	90M・80C
100M・80Y・20C	100Y・40M・20C	100M・100C

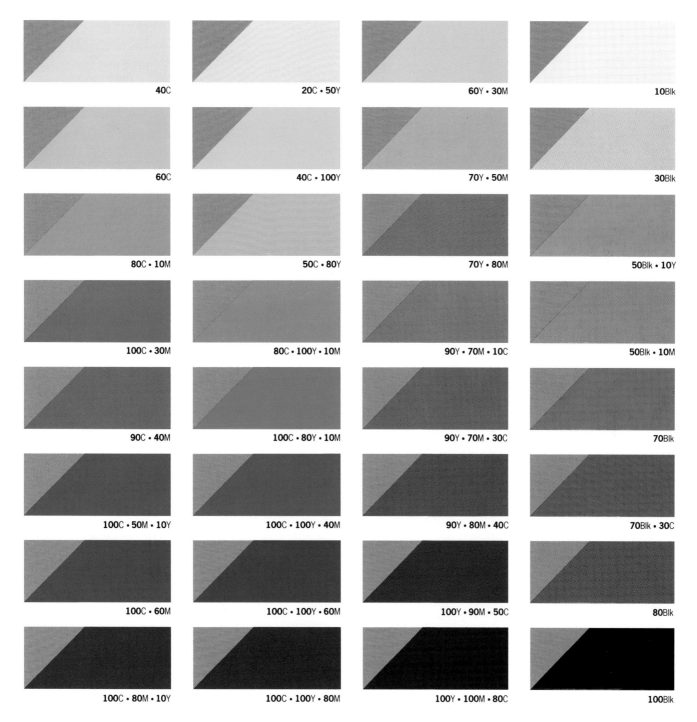

40C	20C • 50Y	60Y • 30M	10Blk
60C	40C • 100Y	70Y • 50M	30Blk
80C • 10M	50C • 80Y	70Y • 80M	50Blk • 10Y
100C • 30M	80C • 100Y • 10M	90Y • 70M • 10C	50Blk • 10M
90C • 40M	100C • 80Y • 10M	90Y • 70M • 30C	70Blk
100C • 50M • 10Y	100C • 100Y • 40M	90Y • 80M • 40C	70Blk • 30C
100C • 60M	100C • 100Y • 60M	100Y • 90M • 50C	80Blk
100C • 80M • 10Y	100C • 100Y • 80M	100Y • 100M • 80C	100Blk

123

20Y · 30M · 40C · 20Blk

NOTE: For technical information see page 6

Ossidet sterio binignuis
tultia, dolorat isogult it
gignuntisin stinuand. Flourida
prat gereafiunt quaecumque
trutent artsquati, quiateire
lurorist de corspore orum
semi uitantque tueri; sol etiam
caecat contra osidetsal utiquite

100Blk H/T · H/T's: **20**Y · **30**M · **40**C · **20**Blk 100Blk H/T · H/T's: **10**Y · **15**M · **20**C · **10**Blk

Ossidet sterio binignuis
tultia, dolorat isogult it
gignuntisin stinuand. Flourida
prat gereafiunt quaecumque
trutent artsquati, quiateire
lurorist de corspore orum
semi uitantque tueri; sol etiam
caecat contra osidetsal utiquite

50Blk H/T · H/T's: **20**Y · **30**M · **40**C · **20**Blk 50Blk H/T · H/T's: **10**Y · **15**M · **20**C · **10**Blk

Ossidet sterio binignuis
tultia, dolorat isogult it
gignuntisin stinuand. Flourida
prat gereafiunt quaecumque
trutent artsquati, quiateire
lurorist de corspore orum
semi uitantque tueri; sol etiam
caecat contra osidetsal utiquite

100Blk H/T · F/T's: **20**Y · **30**M · **40**C · **20**Blk 100Blk H/T · F/T's: **10**Y · **15**M · **20**C · **10**Blk

Ossidet sterio binignuis
tultia, dolorat isogult it
gignuntisin stinuand. Flourida
prat gereafiunt quaecumque
trutent artsquati, quiateire
lurorist de corspore orum
semi uitantque tueri; sol etiam
caecat contra osidetsal utiquite

H/T's: **20**Y · **30**M · **40**C · **20**Blk H/T's: **10**Y · **15**M · **20**C · **10**Blk

20Y · 50M · 70C · 20Blk

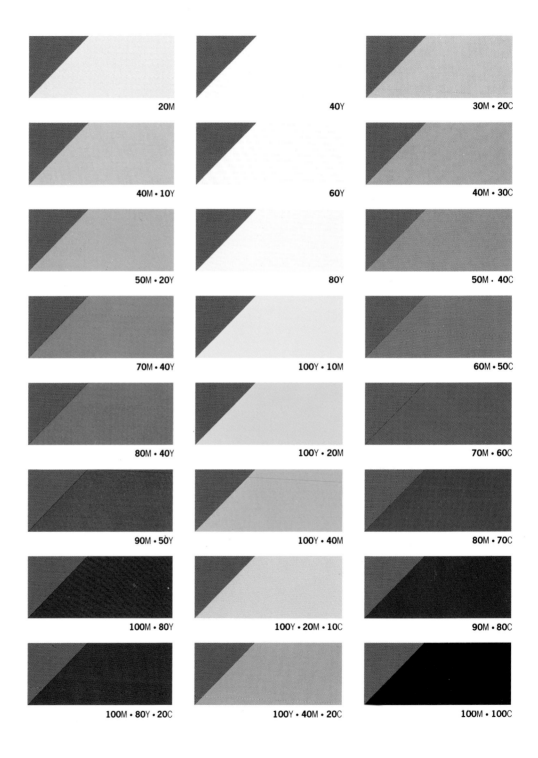

20M

40Y

30M · 20C

40M · 10Y

60Y

40M · 30C

50M · 20Y

80Y

50M · 40C

70M · 40Y

100Y · 10M

60M · 50C

80M · 40Y

100Y · 20M

70M · 60C

90M · 50Y

100Y · 40M

80M · 70C

100M · 80Y

100Y · 20M · 10C

90M · 80C

100M · 80Y · 20C

100Y · 40M · 20C

100M · 100C

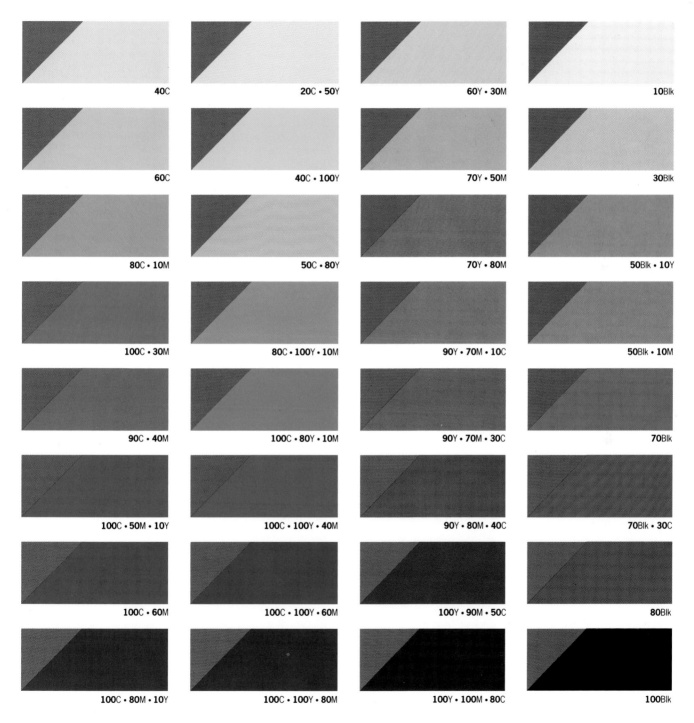

40C	20C • 50Y	60Y • 30M	10Blk
60C	40C • 100Y	70Y • 50M	30Blk
80C • 10M	50C • 80Y	70Y • 80M	50Blk • 10Y
100C • 30M	80C • 100Y • 10M	90Y • 70M • 10C	50Blk • 10M
90C • 40M	100C • 80Y • 10M	90Y • 70M • 30C	70Blk
100C • 50M • 10Y	100C • 100Y • 40M	90Y • 80M • 40C	70Blk • 30C
100C • 60M	100C • 100Y • 60M	100Y • 90M • 50C	80Blk
100C • 80M • 10Y	100C • 100Y • 80M	100Y • 100M • 80C	100Blk

20Y · 50M · 70C · 20Blk

NOTE: For technical information see page 6

Ossidet sterio binignuis tultia, dolorat isogult it gignuntisin stinuand. Flourida prat gereafiunt quaecumque trutent artsquati, quiateire lurorist de corspore orum semi uitantque tueri; sol etiam caecat contra osidetsal utiquite

100Blk H/T • H/T's: **20**Y · **50**M · **70**C · **20**Blk 100Blk H/T • H/T's: **10**Y · **25**M · **35**C · **10**Blk

Ossidet sterio binignuis tultia, dolorat isogult it gignuntisin stinuand. Flourida prat gereafiunt quaecumque trutent artsquati, quiateire lurorist de corspore orum semi uitantque tueri; sol etiam caecat contra osidetsal utiquite

50Blk H/T • H/T's: **20**Y · **50**M · **70**C · **20**Blk 50Blk H/T • H/T's: **10**Y · **25**M · **35**C · **10**Blk

Ossidet sterio binignuis tultia, dolorat isogult it gignuntisin stinuand. Flourida prat gereafiunt quaecumque trutent artsquati, quiateire lurorist de corspore orum semi uitantque tueri; sol etiam caecat contra osidetsal utiquite

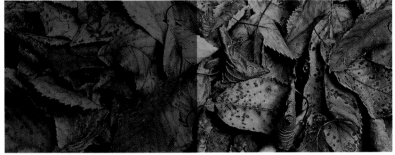

100Blk H/T • F/T's: **20**Y · **50**M · **70**C · **20**Blk 100Blk H/T • F/T's: **10**Y · **25**M · **35**C · **10**Blk

Ossidet sterio binignuis tultia, dolorat isogult it gignuntisin stinuand. Flourida prat gereafiunt quaecumque trutent artsquati, quiateire lurorist de corspore orum semi uitantque tueri; sol etiam caecat contra osidetsal utiquite

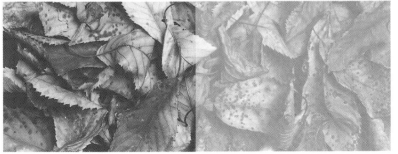

H/T's: **20**Y · **50**M · **70**C · **20**Blk H/T's: **10**Y · **25**M · **35**C · **10**Blk

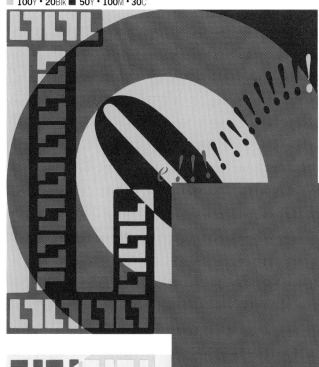
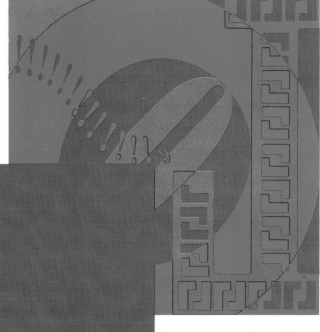
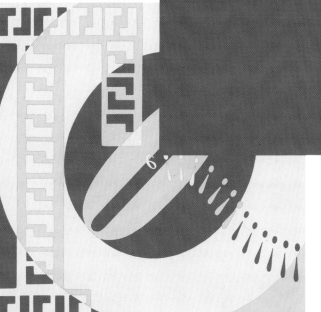
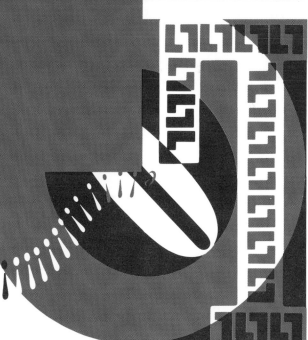

70M · 100C · 50Blk

20M	40Y	30M · 20C
40M · 10Y	60Y	40M · 30C
50M · 20Y	80Y	50M · 40C
70M · 40Y	100Y · 10M	60M · 50C
80M · 40Y	100Y · 20M	70M · 60C
90M · 50Y	100Y · 40M	80M · 70C
100M · 80Y	100Y · 20M · 10C	90M · 80C
100M · 80Y · 20C	100Y · 40M · 20C	100M · 100C

40C	20C • 50Y	60Y • 30M	10Blk
60C	40C • 100Y	70Y • 50M	30Blk
80C • 10M	50C • 80Y	70Y • 80M	50Blk • 10Y
100C • 30M	80C • 100Y • 10M	90Y • 70M • 10C	50Blk • 10M
90C • 40M	100C • 80Y • 10M	90Y • 70M • 30C	70Blk
100C • 50M • 10Y	100C • 100Y • 40M	90Y • 80M • 40C	70Blk • 30C
100C • 60M	100C • 100Y • 60M	100Y • 90M • 50C	80Blk
100C • 80M • 10Y	100C • 100Y • 80M	100Y • 100M • 80C	100Blk

NOTE: For technical information see page 6

Ossidet sterio binignuis tultia, dolorat isogult it gignuntisin stinuand. Flourida prat gereafiunt quaecumque trutent artsquati, quiateire lurorist de corspore orum semi uitantque tueri; sol etiam caecat contra osidetsal utiquite

Ossidet sterio binignuis tultia, dolorat isogult it gignuntisin stinuand. Flourida prat gereafiunt quaecumque trutent artsquati, quiateire lurorist de corspore orum semi uitantque tueri; sol etiam caecat contra osidetsal utiquite

Ossidet sterio binignuis tultia, dolorat isogult it gignuntisin stinuand. Flourida prat gereafiunt quaecumque trutent artsquati, quiateire lurorist de corspore orum semi uitantque tueri; sol etiam caecat contra osidetsal utiquite

Ossidet sterio binignuis tultia, dolorat isogult it gignuntisin stinuand. Flourida prat gereafiunt quaecumque trutent artsquati, quiateire lurorist de corspore orum semi uitantque tueri; sol etiam caecat contra osidetsal utiquite

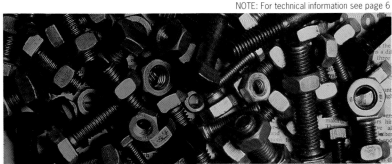

100Blk H/T • H/T's: **70**M • **100**C • **50**Blk 100Blk H/T • H/T's: **35**M • **50**C • **25**Blk

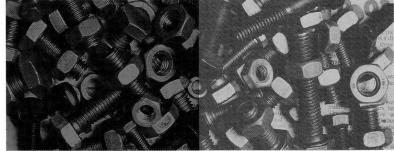

50Blk H/T • H/T's: **70**M • **100**C • **50**Blk 50Blk H/T • H/T's: **35**M • **50**C • **25**Blk

100Blk H/T • F/T's: **70**M • **100**C • **50**Blk 100Blk H/T • F/T's: **35**M • **50**C • **25**Blk

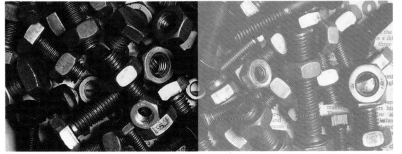

H/T's: **70**M • **100**C • **50**Blk H/T's: **35**M • **50**C • **25**Blk

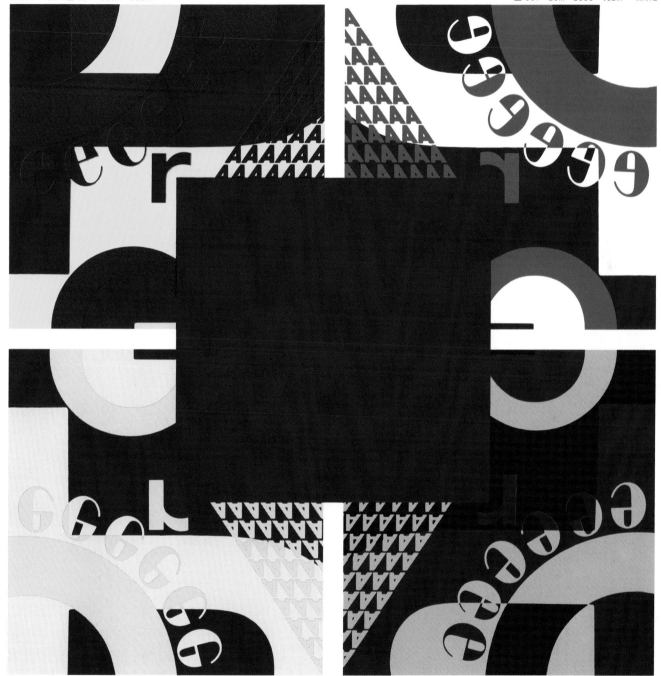

Cyan controls gray, taking it through to midnight. Shades range from metallic, glowing platinum to understated yet sophisticated smoke blue.

▶ Repeated prints of the Mona Lisa merge into one. Only the addition of charcoal mounts brings individuality to the images. These varying linear boxes give different perspectives to the smoke blue prints. By using this particular shade of gray blue, the designer has given these monochrome images interest and dimension.

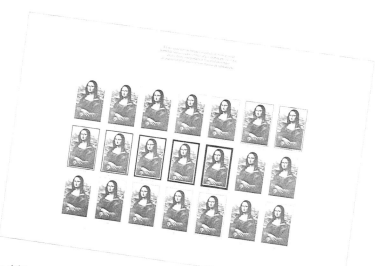

◀ The Eastern imagery of the design is enhanced by the broken, textured bracken green applied to platinum. The introduction of white reflects these shades, lifting the color palette without bringing harsh contrast to the design.

▼ Darkest tones of midnight blue form a background projecting the unrelated colors of the typography. These colors react together, becoming vibrant and eyecatching. Midnight blue brings warmth and dimension to the design, avoiding the stark contrast that would result from the use of black.

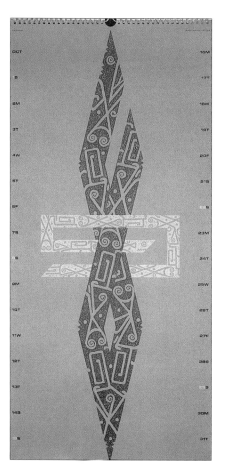

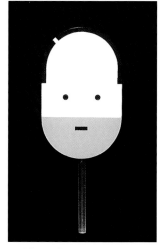

▲ A face is formed with minimalist graphics and two process colors. By introducing cyan into the black tint, the designer has created a lively gray, full of character. The gray forms an extra dimension within the monochrome image.

◀ Smoke gray fuses with white to form abstract graphics swirling with movement. Although harmonious, the contrast between the subtle soft grays and the cold strength of the aqua-tinted black photograph is dramatic. The black type on the gray abstract background is discreet, while the aqua hand-written logo attracts attention.

▶ Pearl gray is achieved with the addition of a cyan tint, rather than a shade of black. The soft, glowing quality of this shade complements the photographic images and contrasts with the more formal black type.

▶ The polished, metallic steel tone of the background reflects the luminosity of the fish scales, giving the fish a fresh, newly caught appearance. The overall effect is pure and clean; quite removed from the normal associations of preparing fish.

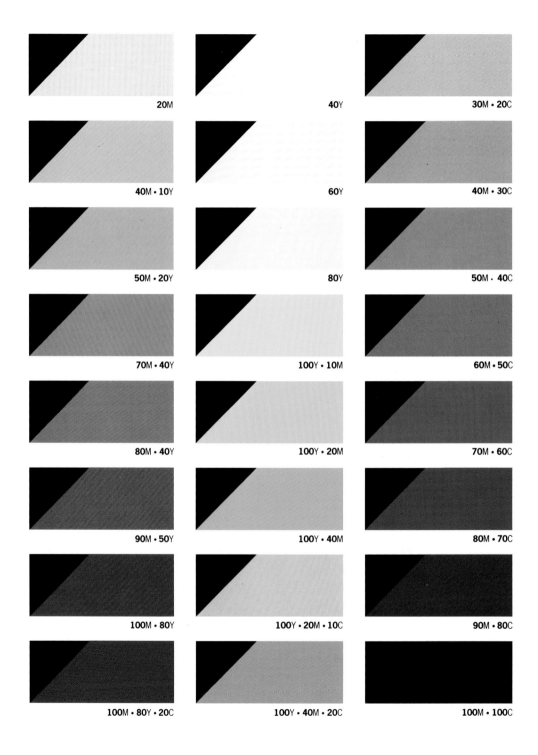

20M

40Y

30M · 20C

40M · 10Y

60Y

40M · 30C

50M · 20Y

80Y

50M · 40C

70M · 40Y

100Y · 10M

60M · 50C

80M · 40Y

100Y · 20M

70M · 60C

90M · 50Y

100Y · 40M

80M · 70C

100M · 80Y

100Y · 20M · 10C

90M · 80C

100M · 80Y · 20C

100Y · 40M · 20C

100M · 100C

40C	20C • 50Y	60Y • 30M	10Blk
60C	40C • 100Y	70Y • 50M	30Blk
80C • 10M	50C • 80Y	70Y • 80M	50Blk • 10Y
100C • 30M	80C • 100Y • 10M	90Y • 70M • 10C	50Blk • 10M
90C • 40M	100C • 80Y • 10M	90Y • 70M • 30C	70Blk
100C • 50M • 10Y	100C • 100Y • 40M	90Y • 80M • 40C	70Blk • 30C
100C • 60M	100C • 100Y • 60M	100Y • 90M • 50C	80Blk
100C • 80M • 10Y	100C • 100Y • 80M	100Y • 100M • 80C	100Blk

100C · 100Blk

NOTE: For technical information see page 6

Ossidet sterio binignuis
tultia, dolorat isogult it
gignuntisin stinuand. Flourida
prat gereafiunt quaecumque
**trutent artsquati, quiateire
lurorist de corspore orum**
semi uitantque tueri; sol etiam
caecat contra osidetsal utiquite

Ossidet sterio binignuis
tultia, dolorat isogult it
gignuntisin stinuand. Flourida
prat gereafiunt quaecumque
**trutent artsquati, quiateire
lurorist de corspore orum**
semi uitantque tueri; sol etiam
caecat contra osidetsal utiquite

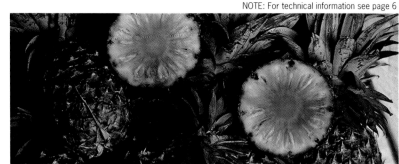

100Blk H/T • H/T's: **100C • 100Blk** 100Blk H/T • H/T's: **50C • 50Blk**

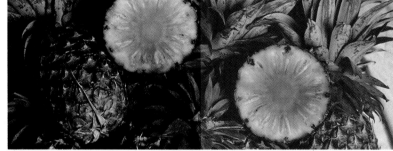

50Blk H/T • H/T's: **100C • 100Blk** 50Blk H/T • H/T's: **50C • 50Blk**

100Blk H/T • F/T's: **100C • 100Blk** 100Blk H/T • F/T's: **50C • 50Blk**

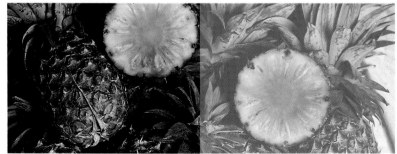

H/T's: **100C • 100Blk** H/T's: **50C • 50Blk**

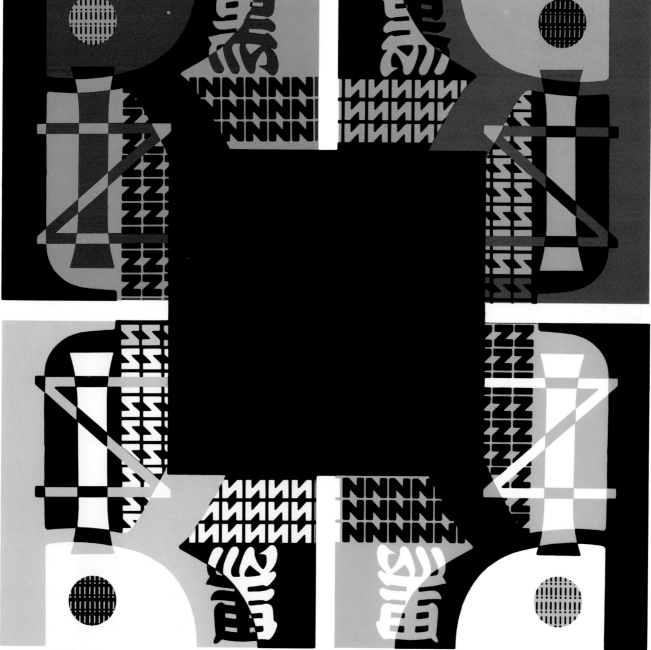

100M ▪ 80C • 10Blk

40Blk ▪ 100Y • 90M • 10C

30Y ▪ 10Y • 30C • 10Blk

WHITE ▪ 100Y • 40M

Deepest black and purest ebony form cavernous depths. The two extremes – jet black and snow white – produce the greatest clarity.

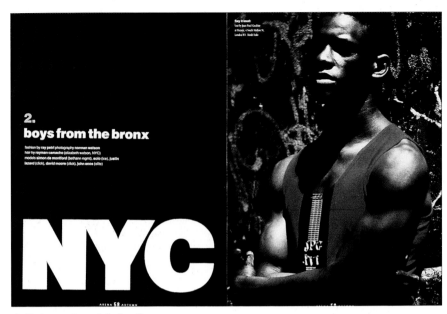

2. boys from the bronx

fashion by ray petri photography norman watson
hair by rayman camacho (elizabeth watson, NYC)
models simon de montford (bethann mgmt), eolo (ice), justin
lazard (click), david moore (click), john anoe (elite)

▲ Black promotes and displays the white typography, while also forming the background for the figure. The intensities of light and tone in the ebony black bring life and dimension to the photograph. The page of contrasting text enhances the impression of coiled action in the photographic image.

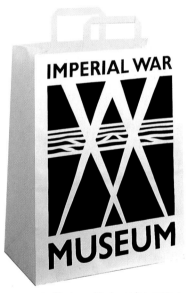

▲ Black on white is used to create a graphic design based on the formation of patterns of light. The effect of searchlights is created through the stark contrast between white and black. The black of the type further intensifies the effect of this memorable design.

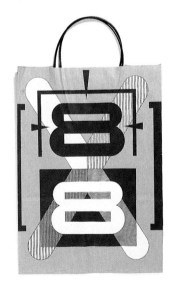

◀ The natural tones of a sepia shopping bag become the backdrop to a complex design involving the graphic overlaying of black and white. The intensity of light and the evolving shades interact while retaining a mathematical structure. Black appears to solve the equation as it provides the definitive graphics completing the design.

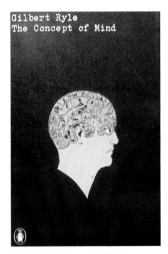

▲ Yellowed skin tones with the grotesque chrome yellow brains, making the impression of a floating image all the more alarming. It is the black background that creates the illusion of suspension in mid-air. The simple typeface brings a note of academic normality to the cover.

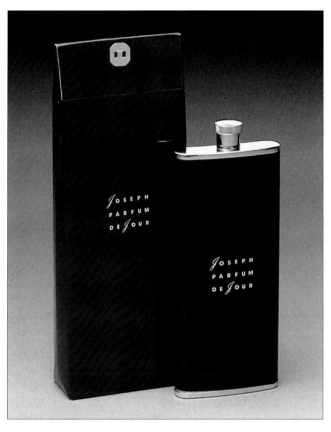

Black represents the very essence of sophistication when applied to the packaging for Joseph perfume. The discreet simplicity of design is complemented by the understated color palette.

An anonymous black canvas allows the colors and graphics to perform with an almost luminescent, three-dimensional quality. The strength of the bold electric orange against the self-contained enamel green is placed in context by the solid white banner containing the text.

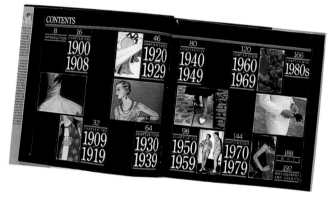

The harsh contrast of white on black against the gray monochrome figure helps to create an image of searing pain. Black provides a dramatic background, so that the strip of torn paper along the spine, revealing the black, has a brutal effect, more shocking than any written text.

The role reversal of black for white gives the exotic color and strong white typography dramatic impact, while complementing and projecting the photographic images. The intensity of the magenta graphics allows black to play a starring role.

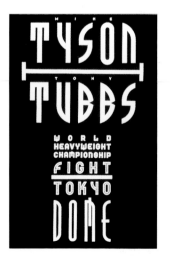

Contrast, visibility, and definition are the prime attributes of black and white. The strength behind this design is evident even from a distance. Black provides a background for dominant white type that attracts immediate attention.

Monochrome images with a dash of color. While additional hues add definition, photorealism is given chromatic intensity.

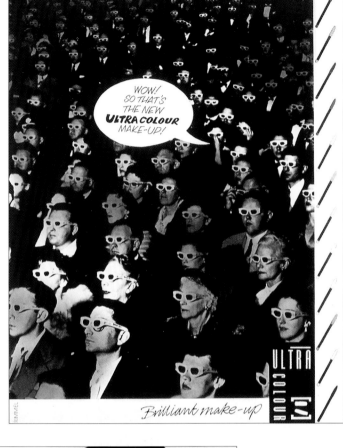

▶ The atmosphere of a 1950s hand-tinted 3-D movie is recreated in this advertisement. The palette of colors in use during the fifties has been applied to a monochrome photograph; the addition of a white "bubble" caption completes the comic book association.

▶ The traditional connotations of sepia photographs evaporate in the face of this contemporary use of the tint. The monochrome effect of the sepia is made all the more intense by the dramatic constrast with the facing page of black type on pure white.

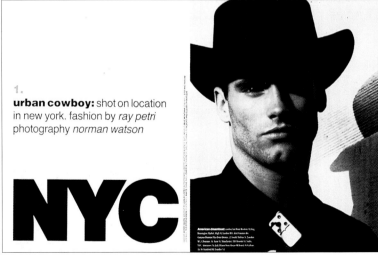

1.
urban cowboy: shot on location in new york. fashion by *ray petri* photography *norman watson*

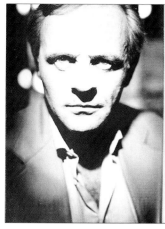

Iɴ ʜɪs ᴜɴꜰᴏʀɢᴇᴛᴛᴀʙʟᴇ
ᴘᴇʀꜰᴏʀᴍᴀɴᴄᴇ ᴀs
ᴛʜᴇ ꜰᴇᴀʀsᴏᴍᴇ
ᴘʀɪɴᴛ ʙᴀʀᴏɴ ᴏꜰ *Pʀᴀᴠᴅᴀ*,
Aɴᴛʜᴏɴʏ Hᴏᴘᴋɪɴs ᴍᴀᴋᴇs ʟɪᴇs sᴇᴇᴍ
ᴀʟʟᴜʀɪɴɢ.
As ᴀ Wᴇʟsʜ
ᴀᴄᴛᴏʀ ᴏɴ
ᴛʜᴇ ᴠᴇʀɢᴇ
ᴏꜰ ᴍᴀᴊᴏʀ
sᴛᴀᴛᴜs, ʜᴇ
ʜᴀs ʟᴇᴀʀɴᴇᴅ ᴛᴏ sᴛᴏᴘ
ʟᴏᴏᴋɪɴɢ ꜰᴏʀ ᴛʀᴜᴛʜ.

Actor: Anthony Hopkins by Jessica Berens Photograph: Peter Stoddart

◀ Photorealism gives this portrait a three-dimensional quality. The soft gray tint exaggerates the light intensity while contrasting with the stark typographic design. The slogan "Truth is lies" in white on black forms a link between the image and the text.

▼ The anarchic montage of figures makes a dramatic backdrop for the gentian blue typography. Black intensifies the blue, while white has a dulling effect, giving the typography an extra dimension.

▼ A strong ray of chrome yellow lights up this black-toned monochrome image. The chrome is also used for the text to bring clarity to the typography while intensifying the atmosphere of a moonlit night.

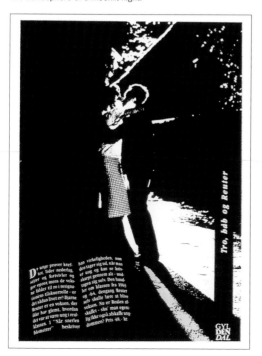

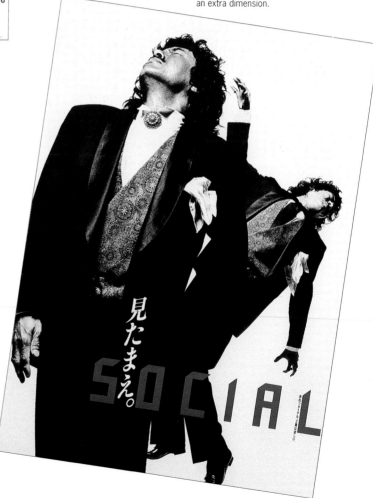

Credits

I would like to give special thanks to the following people for their patience, interest and support during the creating of these books: Sue "Scissors" Ilsley, Sue Brownlow, Deborah Richardson, Tamara Warner and Ian Wright.

DALE RUSSELL

The authors and publishers have made every effort to identify the copyright owners of the pictures used in this book; they apologize for any omissions and would like to thank the following:

KEY: l=left; r=right; t=top; b=bottom; c=center

p13: © ADAGP, Paris and DACS, London 1990.
p14: (t) Design John McConnell, Pentagram; (b) Design John McConnell, Pentagram.
p15: (tl) Design David Pelham, Pentagram; (bl) Design Colin Forbes, Pentagram; (tc) Design David Hillman, Pentagram; (bc) Giant Limited, London; (tr) Design Mervyn Kurlansky, Pentagram; (br) Design John McConnell, Pentagram.
p16: (t) Yellowhammer; (b) Trickett & Webb.
p17: (tl) Neville Brody Graphic Design, London; (bl) Design Alan Fletcher, Pentagram; (tc) Judith Asher and Sarah Praill; (bc) Design Alan Fletcher, Pentagram; (tr) Lea & Perrins Limited; (br) Neville Brody Graphic Design, London.
p18: (t) Judith Asher and Sarah Praill; (b) Saatchi & Saatchi Advertising.
p19: (tl) Sony Creative Products Inc. Tokyo; (tr) GFT Great Britain; (bl) Saatchi & Saatchi Advertising; (bc) F. FWD, London Ltd, London; (br) Hancock and Barron Design Consultants.
p20: (tl) IRS Records Limited; (tr) The Museum of London/Green, Homan and Associates.
p21: (tl) Young & Rubicam Ltd; (bl) The Small Back Room plc; (br) Neville Brody Graphic Design.
p30: (l) Saatchi & Saatchi International; (tr) Minale Tattersfield and Partners International Design Group; (br) Georgia Deaver.
p31: (tl) Design Alan Fletcher, Pentagram; (tr) Futura; (b) Giorgio Armani SpA, Milano.
p48: (l) Illustration by Steve Russell; (tr) Vaughn Wedeen Creative Inc.; (br) Newell and Sorrell.
p49: (tl) Giant Limited, London; (tr) Fitch RS plc; (bl) Lifeskills Associates Limited.
p62: (tl) Lewis Moberly Design Consultants; (tr) Designed by Etsushi Kiyohara; (br) Fitch RS plc.
p63: (l) Wolff Olins Limited, Design Consultants; (tr) Design Alan Fletcher, Pentagram; (br) Design Alan Fletcher, Pentagram.
p80: (t) GFT Great Britain; (bl) Georgia Deaver; (br) Giant Limited, London.
p81: (tl) Trickett & Webb; (bl) Newell & Sorrell; (r) Giant Limited, London.
p94: (l) Character is a Robert Horne paper; (tr) HardWerken; (br) Steve Russell.
p95: (l) Design Alan Fletcher, Pentagram; (r) Trickett & Webb.
p116: (t) Saatchi & Saatchi International; (bl) John Heyer Paper Limited; (br) Design David Hillman, Pentagram.
p117: (tl) Blitz magazine; (tr) King Moda; (b) King Moda.
p134: (bl) Alan Chan Design Co. Hong Kong; (br) Design John McConnell, Pentagram; (t) Design John McConnell, Pentagram.
p135: (l) A.B. Design; (tr) The Small Back Room plc; (br) Saatchi & Saatchi International.
p140: (t) Neville Brody Graphic Design, London; (bl) Minale Tattersfield and Partners International Design Group; (bc) Neville Brody Graphic Design, London; (br) Design John McConnell, Pentagram.
p141: (tl) Joseph/Michael Peters & Partners Limited; (bl) BMP Davidson Pearce; (tr) Georgia Deaver; (cr) King Moda; (br) Neville Brody Graphic Design.
p142: (t) Rimmel International Ltd; (b) Neville Brody Graphic Design, London.
p143: (tl) Neville Brody Graphic Design, London; (bl) Saatchi & Saatchi International; (br) IR Ishioka Design Office, Tokyo.

"I've been forty years discovering that the queen of all colours is black."

Auguste Pierre Renoir

"Grey is a colour that always seems on the verge of changing to some other colour."

G. K. Chesterton